S0-AXW-143

even more great design using 1, 2, & 3 colors

Copyright © 1997 Supon Design Group, Inc., International Book Division

All rights reserved. Copyright under International and
Pan-American copyright conventions.

No part of this book may be reproduced, stored in a retrieval system,
or transmitted in any form or by any means, electronic, mechanical,
photocopying, recording, or otherwise, with out permission of the publisher.

While Madison Square Press makes every effort to publish full and correct
credits for each work included in this volume, sometimes errors of omission
or commission may occur. For this we are most regretful, but hereby must
disclaim any liability.

All of this book is printed in four-color process. A few of the designs
reproduced here may appear to be slightly different from the originals.

ISBN 0-942604-54-7
Library of Congress Catalog Card Number 97-070689
Distributors to the trade in the United States and Canada:
F&W Publications
1507 Dana Avenue
Cincinnati, Ohio 45207

Distributed throughout the rest of the world by:
Hearst Books International
1350 Avenue of the Americas
New York, New York 10019

Published by:
Madison Square Press
10 East 23rd Street
New York, New York 10019

Designed and edited by Supon Design Group, Inc.

Printed in Hong Kong

even more

great

design

using

1,2,&3

colors

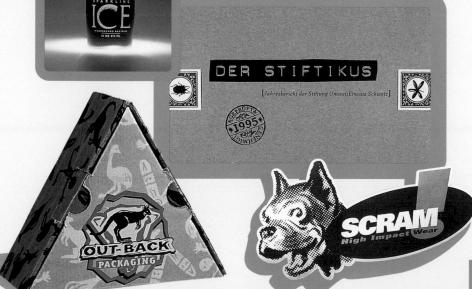

WRITES OF PASSAGE
The Literary Journal for Teenagers

Reaching New Dimensions
with the WORLD WIDE WEB

award winning author
ROBERT CORMIER
SPEAKS OUT

TOP TEEN WRITERS OPEN UP

Rootbeer
SPARKLING
ICE
MICROBREWED ROOTBEER
16 OZ 473 ML

DER STIFTIKUS
[Jahresbericht der Stiftung UmweltEinsatz Schweiz]

GEPRÜFTE
1995
QUALITÄT

OUT-BACK
PACKAGING

SCRAM
High Impact Wear

Supon Design Group

acknowledgments

Project Director	Supon Phornirunlit
Project Manager	Deborah N. Savitt
Jacket Designer	Tom Klinedinst
Book Designers	Alexander Chang, Deborah N. Savitt
Associate Book Designers	Brent Almond, Andrew Berman, Saundrea Cika, Jason Drumheller, Jake Lefebure, Maria Sese Paul, Khoi Vinh
Writer/Editor	Greg Varner
Camera Services	Photo Effects
Staff Photographer	Oi Veerasarn

Front Cover Contributors

From top to bottom:

"Writes of Passage," Vol. 1, No. 3, Michael C. Wang (Page 63)

Talking Rain Sparkling Rootbeer Bottle Packaging, Hornall Anderson Design Works, Inc. (Page 87)

Der Stiftikus Annual Report, Wild & Frey (Page 28)

Scram Stationery, BRD Design (Page 66)

Out-Back Promotional Package, Menasha Corporation—Art Center (Page 144)

Back Cover Contributors

From top to bottom:

Large Animals in Everyday Life Jacket, The University of Georgia Press (Page 126)

Piaman Poster, Kirima Design Office (Page 95)

Other Disciplines Poster, J. Graham Hanson Design (Page 62)

table of contents

introduction

Everybody knows that color can have a profound effect on our emotions. Graphic designers know that color can also have an effect on our wallets—normally, the more colors you use, the more money you lose. Fortunately, a limited color palette needn't have a correspondingly limited influence on our emotions—or on the effectiveness of our designs, as the projects displayed in this book clearly demonstrate.

The precise effect colors have on our emotions is not as simple as grade school truisms—red is exciting, blue is soothing, yellow is happy—would suggest. For one thing, as the painter Josef Albers proposed, the word "red" conjures up fifty different shades in the minds of fifty different people, and some of these shades will be startlingly different from the others. For another, we seldom see any color in isolation. Put soothing blue next to exciting red and what have you got? Something soothing and exciting?

Phenomena associated with color relativity and the interaction of colors aside, we can say with certainty that the work shown in this volume makes effective use of a minimal color palette, whether that palette was chosen as the result of budgetary constraints or for purely aesthetic reasons. Like the previous two titles in this series, *Great Design Using 1, 2, & 3 Colors* and *More Great Design Using 1, 2, & 3 Colors*, we hope this book will serve as an inspiration and reference both to professional designers seeking fresh ideas and to design students hoping to learn more about techniques they can use in their lives beyond school. Additionally, this volume should help readers interested in commercial art learn more about the mechanics of design.

At the same time, this book is a tribute to the skill of the designers who created the work showcased in its pages. Their ability to produce effective, even beautiful, designs with minimal use of color deserves our admiration and gratitude. They make innovative use of techniques such as reverse area printing and half-tone printing, or of materials such as colored paper, to stretch the impact of their projects beyond normal bounds. Designing well is no small feat in itself, but creating a winner despite constraints is truly impressive. (Restraint is an altogether different matter, and should normally be exercised as much as possible!) These designers can juggle all the usual concerns while at work on a project, and also keep in mind such factors as color subtraction and other optical

effects. Most designers are aware of these things, of course, but some are blessed with an especially acute color sense. The work included here is a testament to their talent.

This book can also play a fourth, historical role, offering a perspective on contemporary design trends and practices. Among the projects included in these pages, one can find stationery, posters, packaging, brochures, invitations, and a host of other projects, from the United States, Brazil, Japan, Germany, England, Canada, Hong Kong, and a number of other places around the globe. Out of approximately a thousand submissions, 174 were selected for inclusion in this book.

Based on the evidence of the work included here, certain generalizations may be made. As we saw in the projects included in the first two volumes of this series, when only one color is used, that color tends to be black. Brown kraft paper is still a frequent choice for one-color projects, and black ink is still being applied to it more often than not, but these two familiar elements are now being combined in more satisfying and imaginative ways.

A greater number of submissions were received in the one-color category for this book than in either previous book in the series; we also saw a greater number of successful one-color projects than ever before. A larger variety of materials was used for this batch of projects, and color and paper were combined more creatively.

One more newly identified (and salutary) trend deserves comment. Judging from the pieces submitted for this book, designers seem to be going after a more colorful look for campaigns, irrespective of budgetary constraints. Color palettes may be kept narrow for individual pieces, but colors are combined among components in such thoughtful ways that the whole often seems very colorful indeed.

We hope you'll enjoy *Even More Great Design Using 1, 2, and 3 Colors*. If you have any suggestions about how we can improve our books, or if you would like to contribute work for possible inclusion in future volumes, please contact us.

Supon Phornirunlit, creative director of Supon Design Group, excels in the management of high-profile design projects. A frequent speaker at various industry organizations and universities, Supon attended colleges in Thailand, Japan, and the United States, where he earned his B.A. degree in advertising design. Since Supon Design Group's founding in 1988, Supon and his team of professionals have collected nearly 700 design awards.

About Color Matching

After the release of our first volume, *Great Design Using 1, 2, & 3 Colors,* we received some letters from designers interested in knowing the exact manufacturer colors and numbers that were used in the book. They requested that, in our next volume, we print the numbers of the chips used in each design so that they could experiment with similar applications.

Due to copyright restrictions and the technique used in printing, we regret that our books do not include trademark colors. Our publications are printed using four-color process on a four-color press. This process builds the entire range of colors from four hues.

What appears in our publications, then, are not actual trademark colors, but a very close match to them. In order to use specific manufacturer processses when printing full-color publications, we would have to print hundreds of definitive colors—an economic and organizational nightmare—to associate precise color chips with the design. When publishing books of our scope and magnitude, this option is simply not feasible.

For those interested in precision, you'll find the color chips we have used are similar approximations of the colors represented in your own manufacturer color key books. Colors can be closely matched by placing an actual chip beside our printed "chips." ■

one color

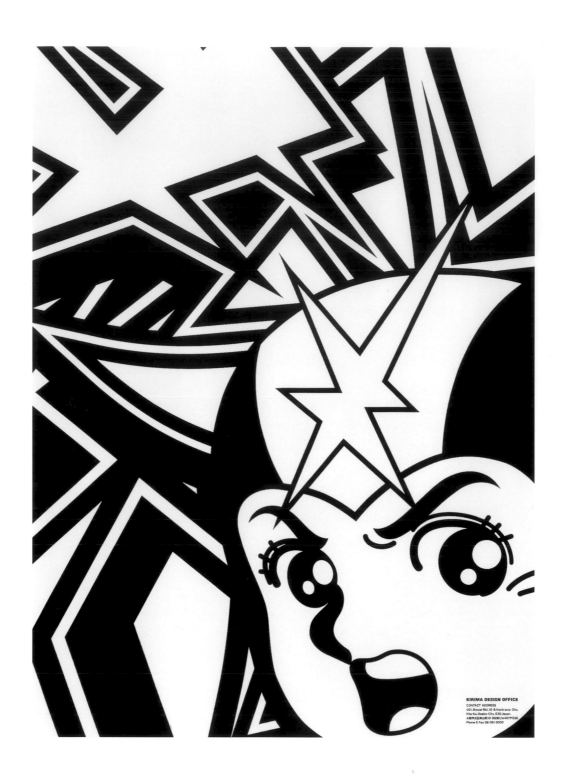

Project	Kirima Design Office Poster
Studio	Kirima Design Office
Art Director	Harumi Kirima
Designers	Harumi Kirima, Fumitaka Yukawa
Client	Kirima Design Office

The designers of this poster chose a striking black on white combination for the way it captured the look of cartoons, suggesting the fun, fresh approach clients can expect from their office.

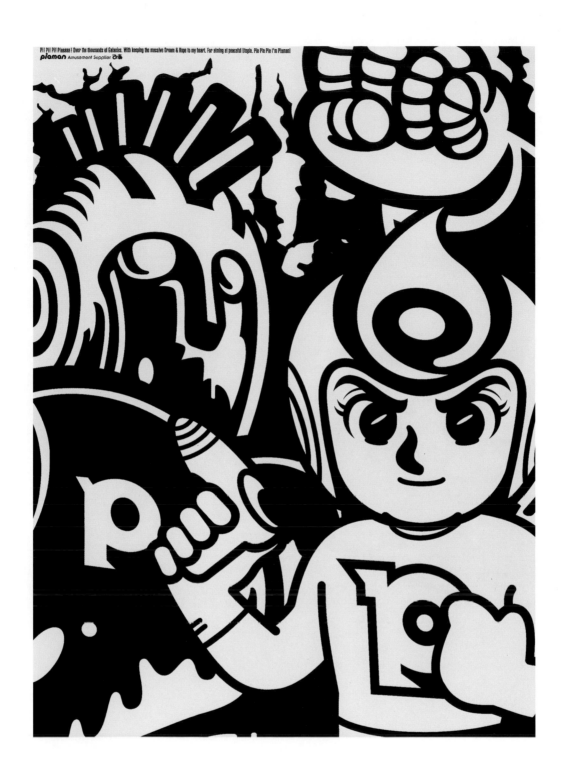

Pi! Pi! Pi! Piaaaaa ! Over the thousands of Galaxies. With keeping the massive Dream & Hope to my heart. For aiming at peaceful Utopia, Pia Pia Pia I'm Piaman!

piaman Amusement Supplier ぴあ

Project	Piaman Poster
Studio	Kirima Design Office
Art Director	Harumi Kirima
Designers	Harumi Kirima and Fumitaka Yukawa
Client	Pia Corporation

This figure, called Piaman, is the mascot of the Pia Corporation, a Japanese entertainment conglomerate. Black and white is used to recreate the look of cartoons.

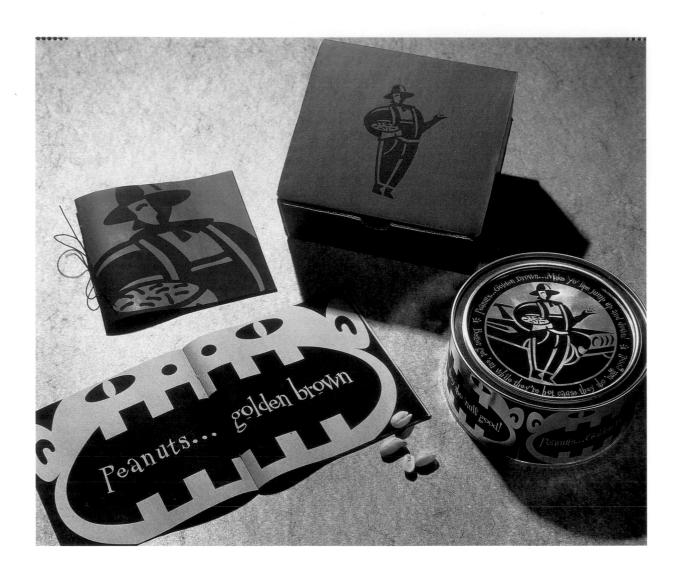

Project	Dogstar Peanuts
Studio	Dogstar
Designer	Rodney Davidson
Illustrator	Rodney Davidson
Copywriter	Rodney Davidson
Client	Dogstar

Peanuts sent to studio clients at holiday time came in this imaginative package. The box is covered with black paper; the figure on the top is silk-screened in black ink. Laser printing was used for the booklet, bound with elastic cording, and on the silver wrapping paper covering the can.

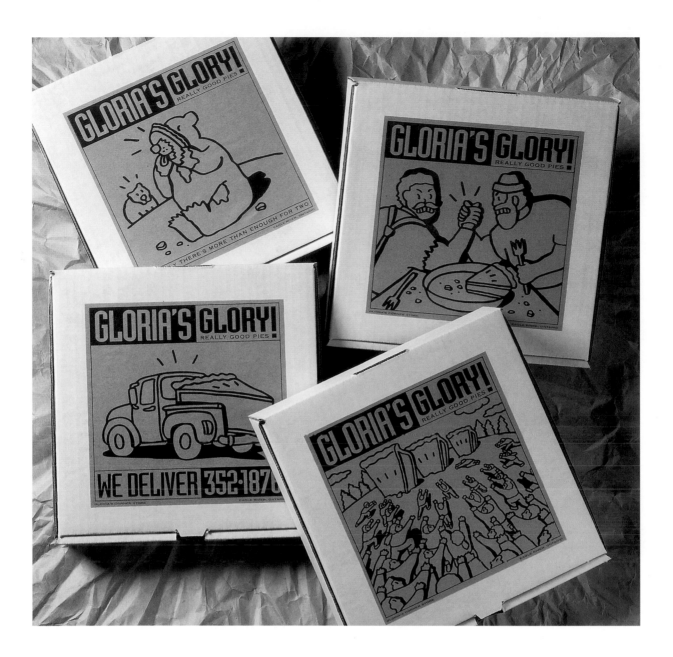

Project	Gloria's Glory
Studio	Bartels & Company, Inc.
Art Directors	David Bartels, Steve Brouwer
Designer	David Bartels
Illustrator	Stephen Schudlich
Client	Gloria's General Store

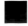

No second color was necessary for these labels, copied on kraft paper and affixed to boxes containing pies. The humorous illustrations and attractive type are an effective combination, suggesting home-made goodness and making these pies look distinctively appetizing.

Project	Bosnia
Studio	Cedomir Kostovic
Art Director	Cedomir Kostovic
Designer	Cedomir Kostovic
Silkscreen Print	Ken Daley
Illustrator	Cedomir Kostovic
Client	Art and Design Department SMSU

Sinking the type in a flood of color was an inspired solution for this political poster. No color other than red was needed. In a simple and effective image, we see the country drowning in a sea of blood.

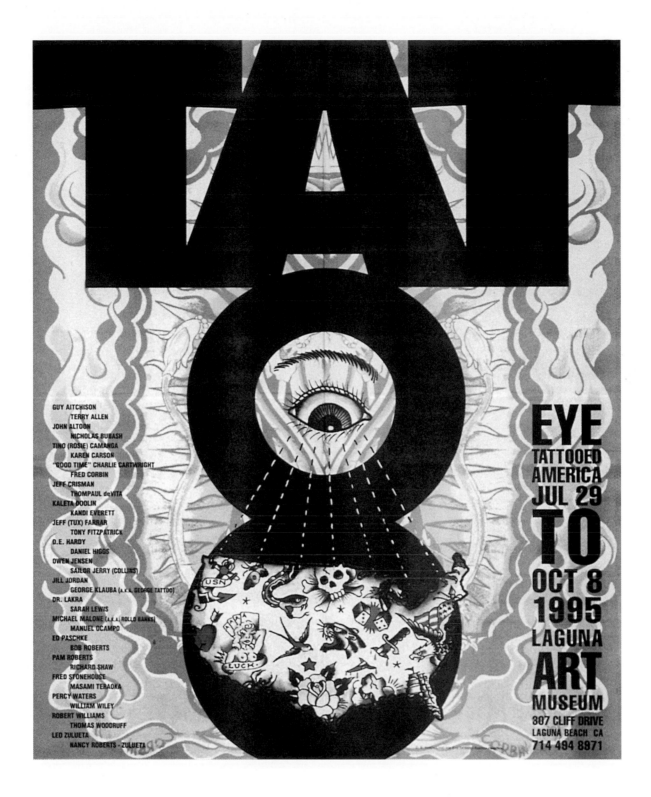

Project	"Eye Tattooed America" Exhibition Announcement/Poster
Studio	Mike Salisbury Communications
Art Director	Mike Salisbury
Designer	Mary Evelyn McGough
Illustrators	George Klauba and D. E. Hardy (tattoo art)
Client	The Laguna Art Museum

For proof that regular newsprint can still make a strong impression, one need look no further than this announcement for an exhibit of tattoo-related art at the Laguna Art Museum.

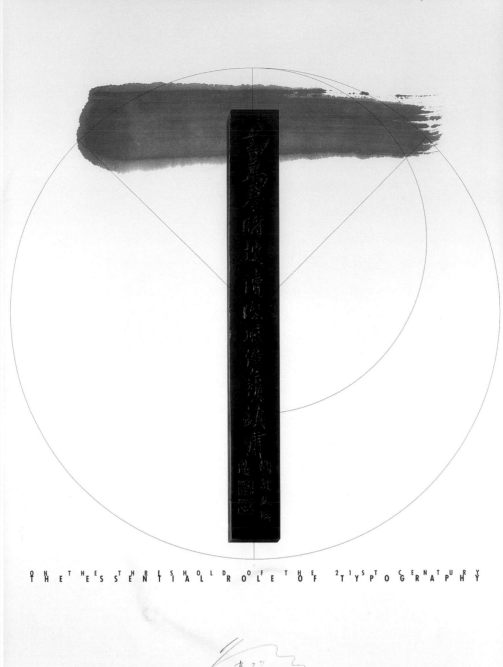

ON THE THRESHOLD OF THE 21ST CENTURY
THE ESSENTIAL ROLE OF TYPOGRAPHY

KAN TAI-KEUNG

Project	On the Threshold of the 21st Century—
	The Essential Role of Typography
Studio	Kan & Lau Design Consultants
Art Director	Kan Tai-keung
Designers	Kan Tai-keung and Pamela Law Pui-hang
Photographer	C. K. Wong
Calligraphy	Kan Tai-keung
Client	Japan Typography Association

Interesting typography and a tension between mechanical and organic elements make this piece a winner. The designers made elegant use of a halftone screen process to achieve this deceptively

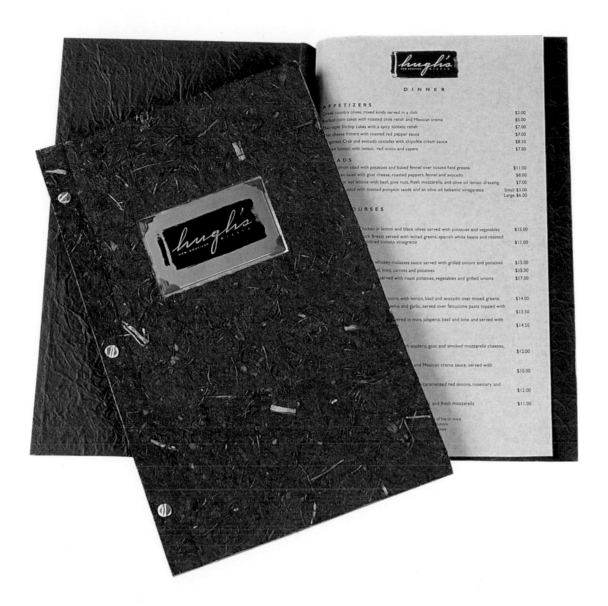

Project	Hugh's Menu
Studio	Ellen Bruss Design
Art Director	Ellen Bruss
Designers	Ellen Bruss and Dae Knight
Hand Assembly	Brian Goddert
Client	Hugh's New American Bistro

This handsome menu shows how unexpected materials can be combined to make a refreshing and distinctive presentation. The logo was silkscreened with black ink on the metal plate, giving this a clean, minimal quality, and relying on the material for the rest of the color.

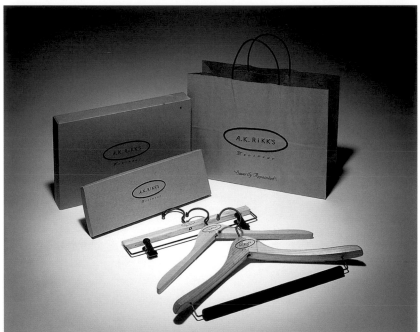

Project A. K. Rikks Menswear Identity
Studio Palazzolo Design Studio
Art Directors Gregg Palazzolo and Mark Siciliano
Designer Gregg Palazzolo
Photographers Andrew Terzes and Chuck Heiney
Client A. K. Rikks Menswear

Packaging materials for this menswear retailer were effectively color-coordinated with its identity. The simplicity of the letterhead and the details of the packaging, such as the logo on the hanger and the black string around the tie box, are integrated for an elegant, first-class piece.

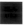

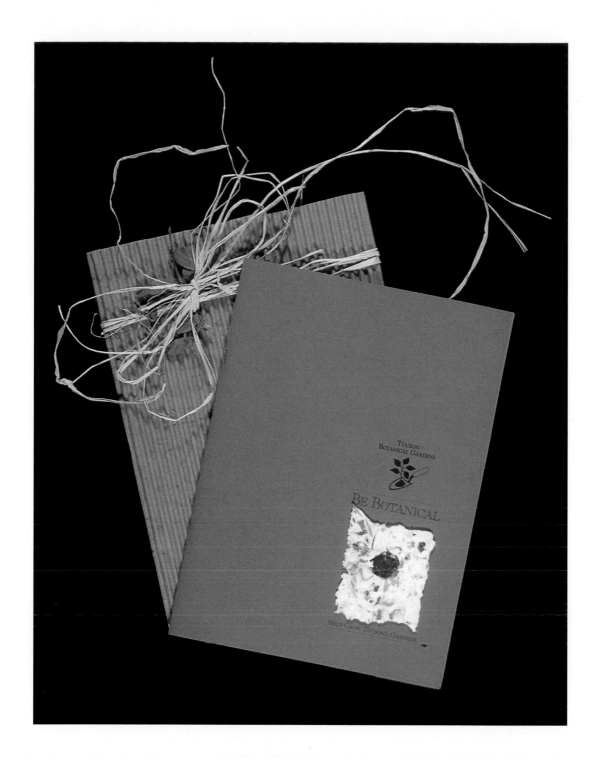

Project	Be Botanical Development Campaign
Studio	Theresa Reindl Bingham
Art Director	Theresa Reindl Bingham
Designer	Theresa Reindl Bingham
Contributors	Jan McIntire and Judy Davidson
Illustrator	Theresa Reindl Bingham
Client	Tucson Botanical Barden

The "found object" quality of this piece makes a unique impression. Handmade papers combine with other papers of differing colors to make a handsome and classy finished product. Simple materials used with flair make all the difference.

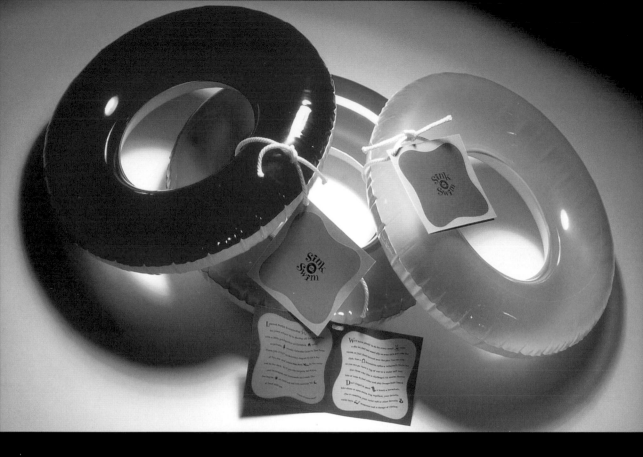

Project	Sink or Swim Party Invitation
Studio	Lambert Design
Art Director	Christie Lambert
Designer	Joy Cathey Price
Photographer	Richard Reens
Illustrator	Joy Cathey Price
Copywriter	Joy Cathey Price
Client	Lambert Design

Project	Nike Price List Fall '96
Studio	Matite Giovanotte
Art Director	Stefania Adani
Photographer	Nike File
Client	Nike Italy

It should be no surprise that even large companies today seek to cut costs. This price list brochure, done in black only, was part of Nike's European seasonal catalogues for footwear, apparel, and accessories—and was very effective, even in one color.

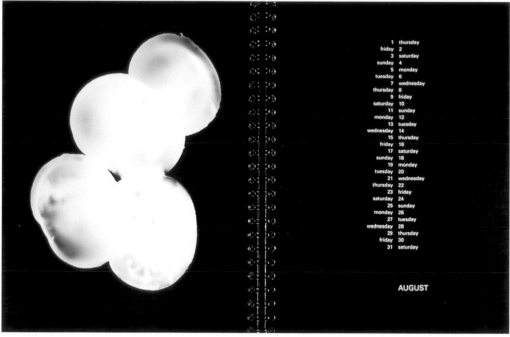

	1	thursday
friday	2	
	3	saturday
sunday	4	
	5	monday
tuesday	6	
	7	wednesday
thursday	8	
	9	friday
saturday	10	
	11	sunday
monday	12	
	13	tuesday
wednesday	14	
	15	thursday
friday	16	
	17	saturday
sunday	18	
	19	monday
tuesday	20	
	21	wednesday
thursday	22	
	23	friday
saturday	24	
	25	sunday
monday	26	
	27	tuesday
wednesday	28	
	29	thursday
friday	30	
	31	saturday

AUGUST

Project	1996 Calendar
Studio	Ellen Kyung Kim
Art Director	Kristin Sommese
Designer	Ellen Kyung Kim
Photographer	Ellen Kyung Kim
Client	Ellen Kyung Kim

The unexpected use of black only makes this calendar surprising and dramatic, an art object as much as a practical item for everyday use. The days and dates of each month are arranged symmetrically along a spine, which also helps give commonplace information a fresh look.

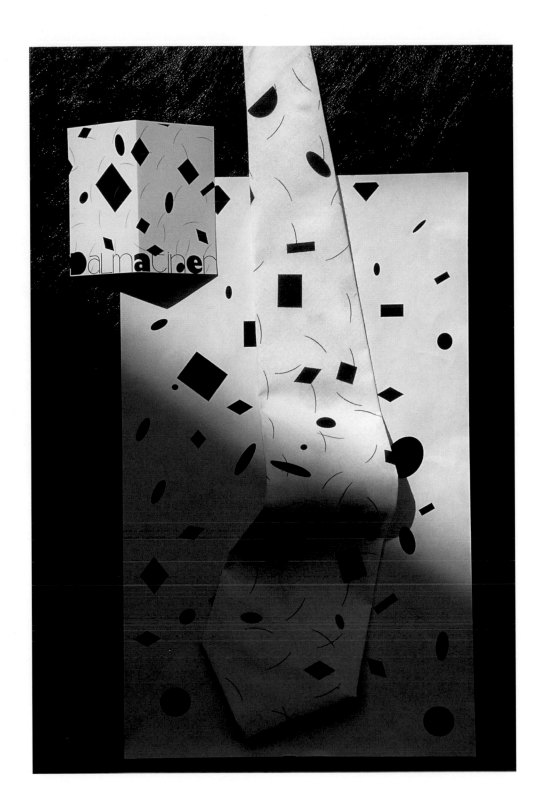

Project	Dalmatiner Tie
Studio	Studio International
Art Director	Boris Ljubicic
Designer	Boris Ljubicic
Illustrator	Boris Ljubicic
Photographer	Boris Ljubicic
Client	Croata

A beautiful Croatian dog breed is well known internationally as the Dalmatian. Designed in honor of these handsome canines, this tie needed no color other than black on white fabric to call the dogs to mind.

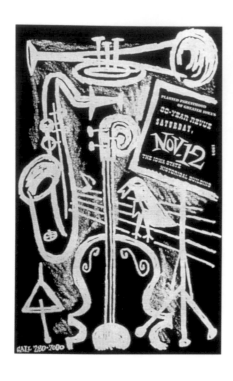
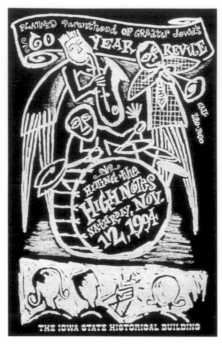
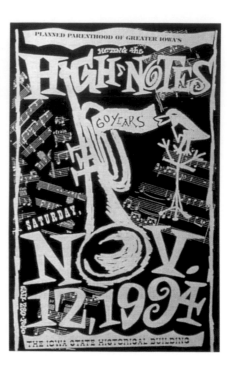

Project	Hitting the High Notes
Studio	Sayles Graphic Design
Art Director	John Sayles
Designer	John Sayles
Illustrator	John Sayles
Client	Planned Parenthood of Greater Iowa

A colored linen paper stock was used to add depth to this design and to enhance the metallic inks. These techniques resulted in a highly satisfying finished piece, very bold and effective.

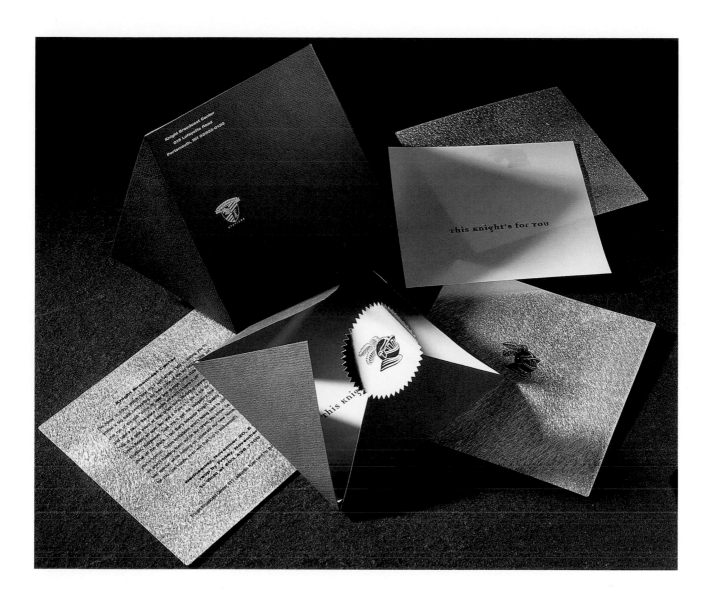

Project	Knight Quality Stations Open House Invitation
Studio	Brown & Company Graphic Design Studio
Art Director	Mary Johanna Brown
Designers	Alicen Brown, Claudia Kaerner
Writer	Chris Lamy
Hand Finishing	Nathan Greeley
Client	Knight Quality Stations

This invitation has an overall sophistication and formality, while retaining its sense of humor. Color was kept at a minimum in order to emphasize the brushed aluminum. Elegant, simple and strong, black made a stark contrast to the aluminum.

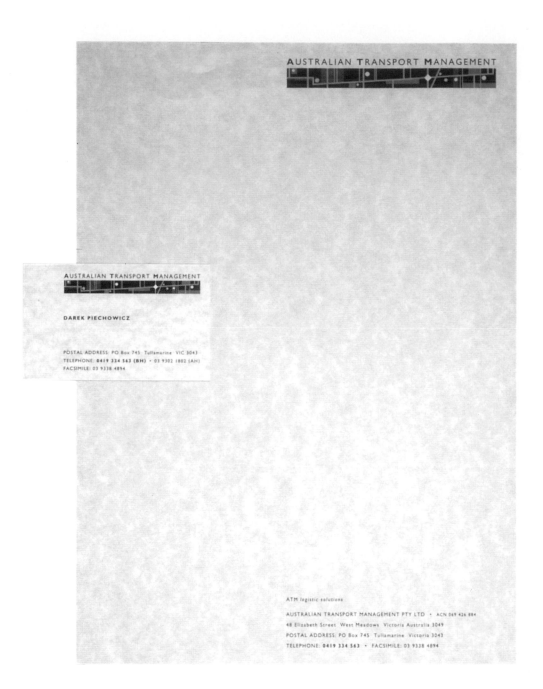

Project	Australian Transport Management
Studio	Mammoliti Chan Design
Art Director	Tony Mammoliti
Designers	Chwee Kuan Chan and Tony Mammoliti
Illustrator	Chwee Kuan Chan
Printer	Toth Bienk & Associates
Client	Australian Transport Management

Just as Australian Transport Management makes the complex nature of public transportation simple, this solution takes the same approach. Paper plays a strong role, too; the parchment adds a classic look, while the logo is up-to-date.

KRAKOVSKI NASIP 22

1000 LJUBLJANA

tel + fax: 061/210 051
mobitel: 0609/628 361

E D I (B) E R K

E D I (B) E R K

KRAKOVSKI NASIP 22

1000 LJUBLJANA

tel + fax: 061/210 051
mobitel: 0609/628 361

Project	Edi Berk Stationery
Studio	KROG
Art Director	Edi Berk
Designer	Edi Berk
Client	Edi Berk

Though designer Edi Berk's studio stationery was printed
in full-color, he wanted something memorable and dramatic
for himself. The solution was this playful stationery, making
especially effective use of reverse printing in the inkblot.

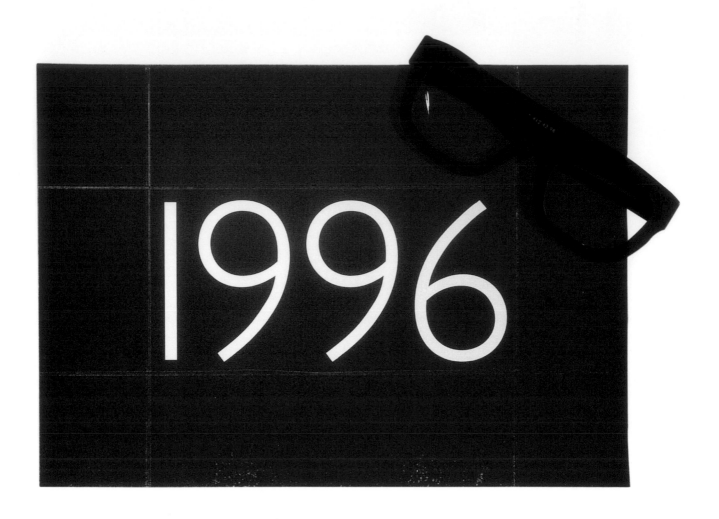

Project	La Vie en Rose
Studio	Sonsoles Llorens Graphic Design
Art Director	Sonsoles Llorens
Designer	Sonsoles Llorens
Client	Sonsoles Llorens

Optimistic wishes for the new year came with rose-colored glasses in this cleverly designed promotional piece. The outer envelope is printed in pink on white paper, then scored and folded. The die-cut black glasses, with pink cellophane lenses, are silkscreened with the same pink ink.

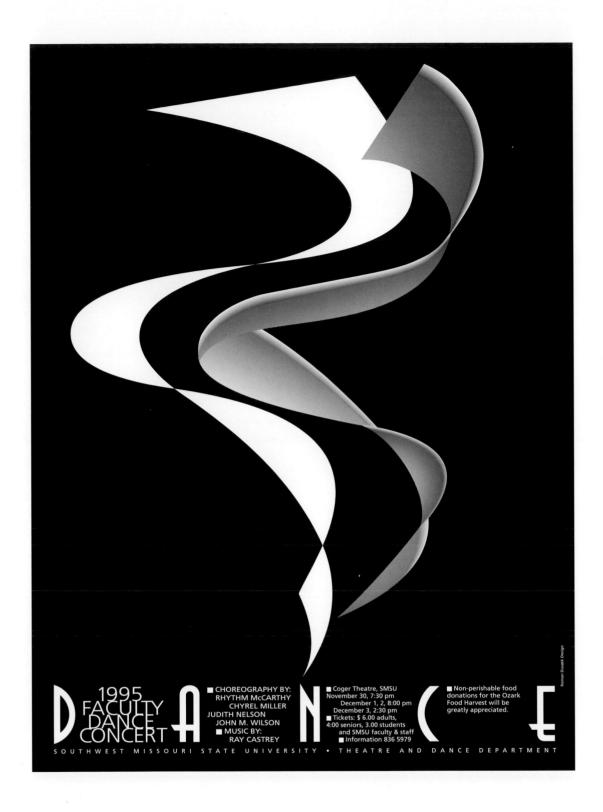

Roman Duszek Design

1995
FACULTY
DANCE
CONCERT

■ CHOREOGRAPHY BY:
RHYTHM McCARTHY
CHYREL MILLER
JUDITH NELSON
JOHN M. WILSON
■ MUSIC BY:
RAY CASTREY

■ Coger Theatre, SMSU
November 30, 7:30 pm
December 1, 2, 8:00 pm
December 3, 2:30 pm
■ Tickets: $ 6.00 adults,
4:00 seniors, 3.00 students
and SMSU faculty & staff
■ Information 836 5979

■ Non-perishable food
donations for the Ozark
Food Harvest will be
greatly appreciated.

DANCE

SOUTHWEST MISSOURI STATE UNIVERSITY • THEATRE AND DANCE DEPARTMENT

Project	Dance
Studio	Roman Duszek
Art Director	Roman Duszek
Designer	Roman Duszek
Illustrator	Roman Duszek
Client	Southwest Missouri State University

This simple and elegant poster, done in black only, makes clever use
of gradation. Apart from budgetary considerations, there was another
factor making this an especially appropriate solution: the stage
design and costumes for this program were also in black and white.

21

This
holiday season,
Mires Design
is giving
people a
helping hand.

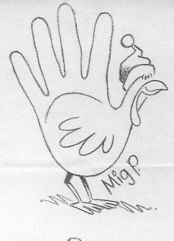

Mig P.

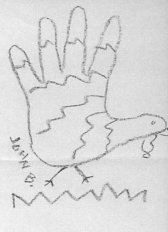

John B.

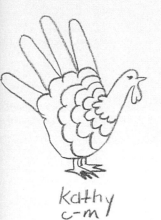

Kathy
c-m

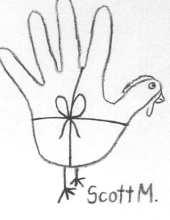

Scott M.

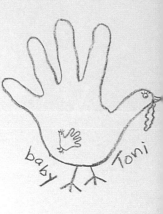

baby Toni

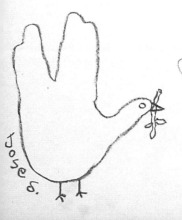

Jose S.

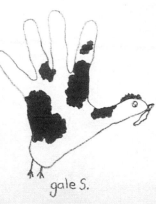

gale S.

The holidays
are a time of giving.
So this year, we're donating
over a ton of turkeys to

San Diego Youth Involvement
Saint Vincent De Paul
Border View YMCA
Emergency Assistance Program
Fraternity House
San Diego Catholic Worker
YWCA Oz San Diego
San Diego Rescue Mission
Project Safehouse
Team ELAN
San Diego Hospice

May your own holidays
be filled with blessings
by the handful.

Project	Mires Design Christmas Card
Studio	Mires Design, Inc.
Art Director	Jose Serrano
Designer	Jose Serrano
Illustrators	Mires Design Staff
Client	Mires Design, Inc.

This oversized holiday greeting is a poster, very different from the
usual, more colorful holiday card. Personalized and unique, it was
also economical to produce. Each turkey was designed to reflect
the "helping hand" theme, and invited coloring by recipients.

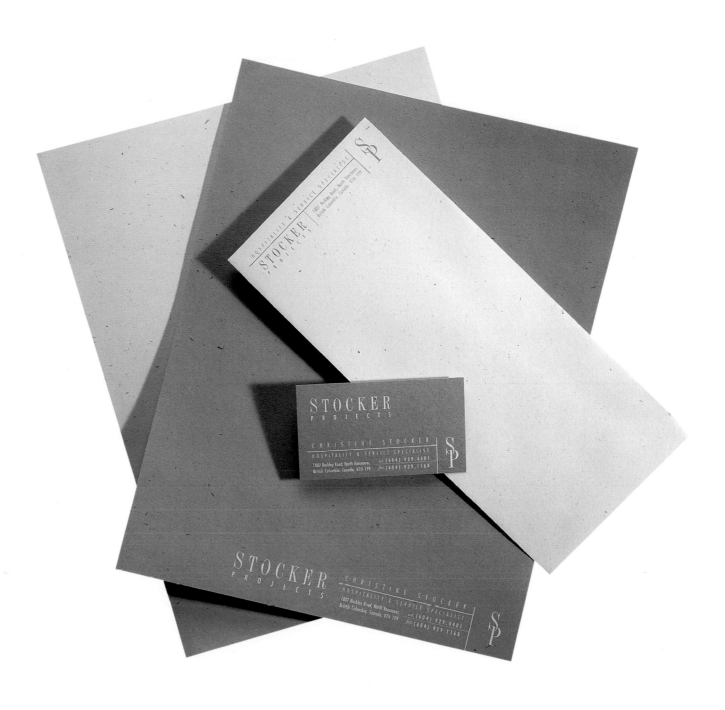

Project	Christine Stocker Stationery
Studio	Hangar 18 Creative Group
Art Director	Sean Carter
Designer	Sean Carter
Photographer	Patrick Hattenberger
Client	Christine Stocker

The client wanted something that was simple, flexible, and could easily tie in to future collateral pieces. This impressive solution called for reverse printing on the letterhead and business card, creating an eye-catching contrast with the natural envelope.

23

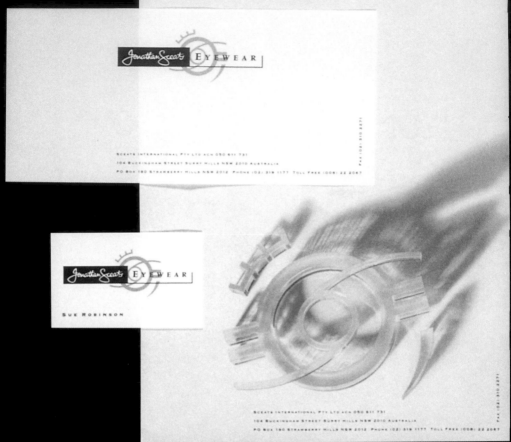

Project	Jonathan Sceats Eyewear
Studio	Harcus Design
Art Director	Annette Harcus
Designer	Stephanie Martin
Photographer	Keith Arnold
Client	Jonathan Sceats

This unusual letterhead, perfect for the client, makes good use of halftone. Sceats creates designer eyewear; for his stationery, black was chosen for its elegant, chic quality.

Project	Whole My Country
Studio	Studio International
Art Director	Boris Ljubicic
Designer	Boris Ljubicic
Photographer	Boris Ljubicic
Illustrator	Boris Ljubicic
Client	HRT, Croatian Radiotelevision

 This oversized poster, pasted on to a construction site, was perfect for a political subject—dramatic and a bit austere. Done in black halftones, it creates a vivid contrast with its environment.

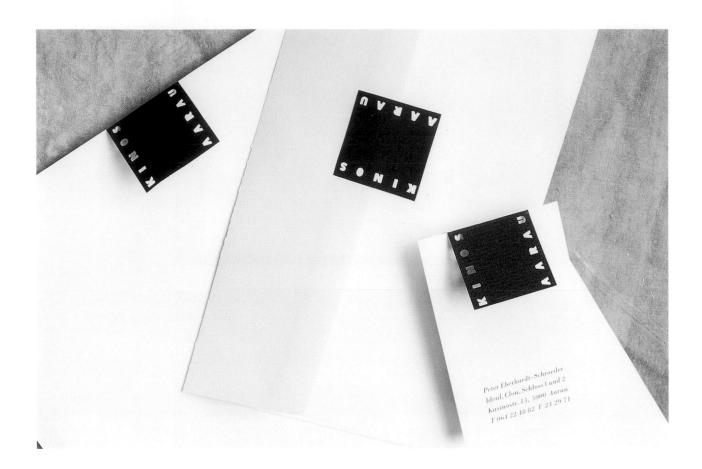

Project	Kinos Aarau Stationery
Studio	Wild & Frey
Art Director	Heinz Wild
Designers	Heinz Wild and Marietta Albinus
Client	Kinos Aarau

 No restriction of color use was necessary for this clever and appropriate stationery. Kinos Aarau is a movie theater; only one color, black, was required to show a die-cut strip of film.

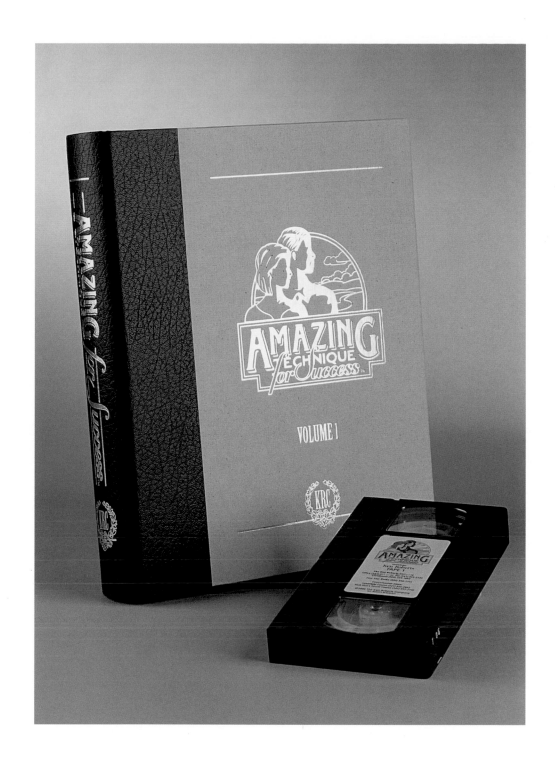

Project	Amazing Technique for Success
Studio	Shields Design
Art Director	Charles Shields
Designer	Charles Shields
Illustrator	Charles Shields
Client	The Ken Roberts Company

A simple graphic was stamped in gold foil on this container for videotapes. This is a classic instance of material supplying color to support and complement a graphic.

Project Der Stiftikus Annual Report
Studio Wild & Frey
Art Directors Lucia Frey and Heinz Wild
Designers Lucia Frey and Heinz Wild
Client Stiftung Umwelteinsatz Schweiz

Standard black ink was printed on recycled paper for this annual
report for an environmental protection foundation. It can be
mailed without an envelope, and its reduced size also cut costs.

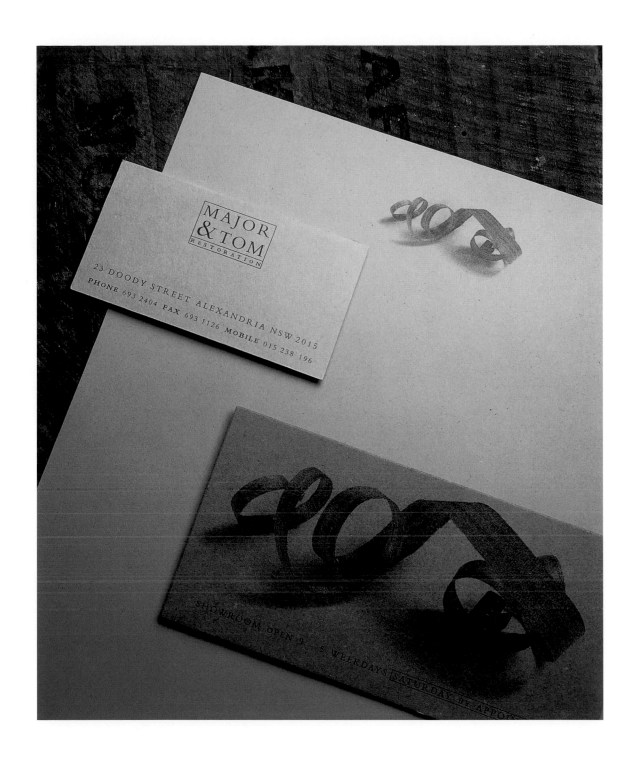

Project	Major & Tom stationery
Studio	MaD House Design
Art Director	Michelle Pullen
Designers	Michelle Pullen and Donna Cavanough
Photographer	Willem Rethmeier
Client	Major & Tom

Budgetary constraints limited the color palette for this project, but the solution is so inspired that no one would ever know it. One color of ink was printed on paper of different colors for each component in the set, and an appropriate graphic was used. Nothing else is needed!

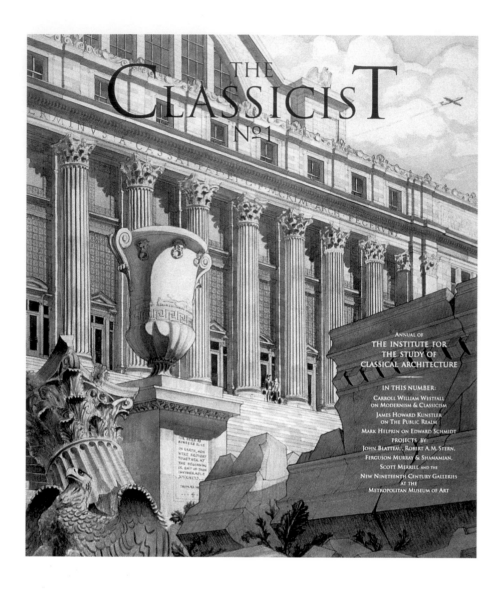

Project The Classicist #1
Studio Seth Joseph Weine
Art Director Seth Joseph Weine
Designer Seth Joseph Weine
Illustrator Richard Cameron (cover)
Client Institute for the Study of Classical Architecture

Elegant typography and attractive layout combine to give
this publication a distinguished and upscale look appropriate
to its subject manner. The beautiful cover attracts and rewards
attention all by itself.

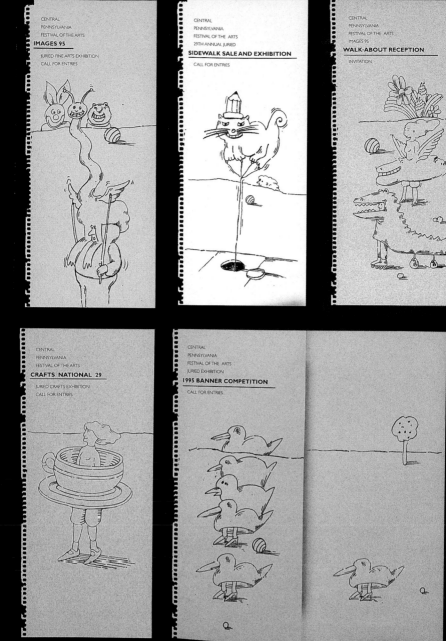

Project	Series of Call-for-Entry Brochures
Studio	Sommese Design
Art Director	Lanny Sommese
Designer	Nathalie Renard
Illustrator	Lanny Sommese
Client	Central Pennsylvania Festival of the Arts

This series of call-for-entry brochures is surprisingly lively and fun. The images for these brochures are taken from a full-color poster, lending stylistic unity to the set while at the same time adding variety.

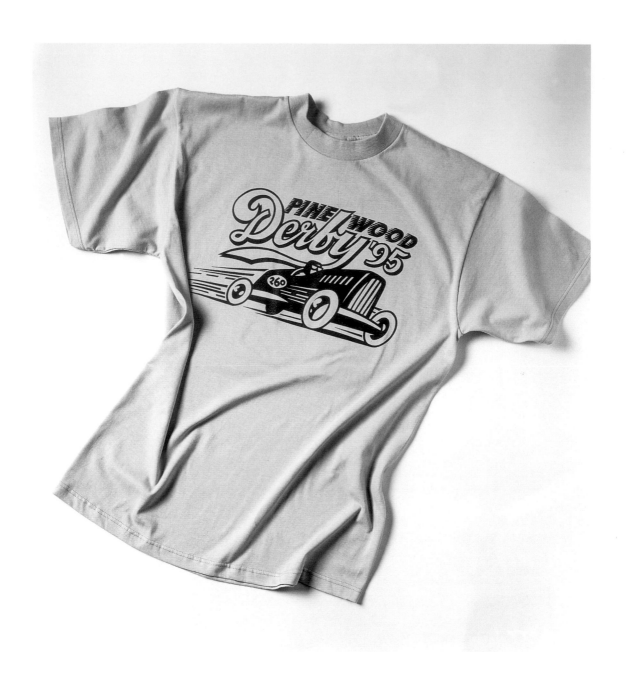

Project	Annual Pinewood Derby T-shirt
Studio	Mires Design, Inc.
Art Director	Jose Serrano
Designer	Jose Serrano
Illustrator	Tracy Sabin
Client	Boy Scout Troop 260

The combination of a bold graphic and the color of the fabric make this a very effective one-color job. The finished T-shirt has a nostalgic look, clearly suggesting the traditional nature of the event.

Frank Owens and Margaret Burke are pleased to announce that their daughter Audrey has a brand new baby brother

Francis Sylvester Owens IV
Two Twenty One pm
Seven Pounds Four Ounces
February Twenty Fifth
Nineteen Hundred Ninety Six
Mount Sinai New York City

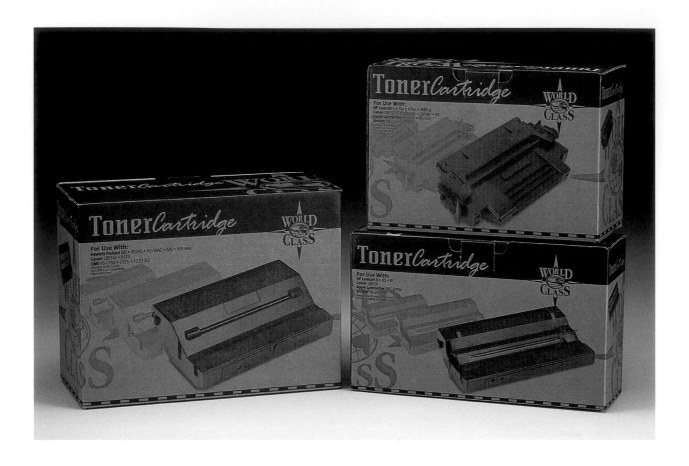

Project	Toner Cartridge Packaging
Studio	Menasha Corporation—Art Center
Art Director	Ric Hartman
Designer	Gary Hughes
Photographer	BBD Photography
Client	Sierra Products

 This toner cartridge packaging is effective and different, using the product itself as a visual. Printed on the brown box, the image of the toner cartridge is a surprisingly attractive graphic element.

Project	Henry V, Richard III poster
Studio	Sommese Design
Art Director	Lanny Sommese
Designers	Lanny Sommese and Kristin Sommese
Illustrator	Lanny Sommese
Client	Penn State

"Although we could have added a second color, it was my feeling that it looked 'added on,' and I decided to save the client the money," designer Lanny Sommese said of this poster, created to advertise two plays—depending on which end was up—for the price of one.

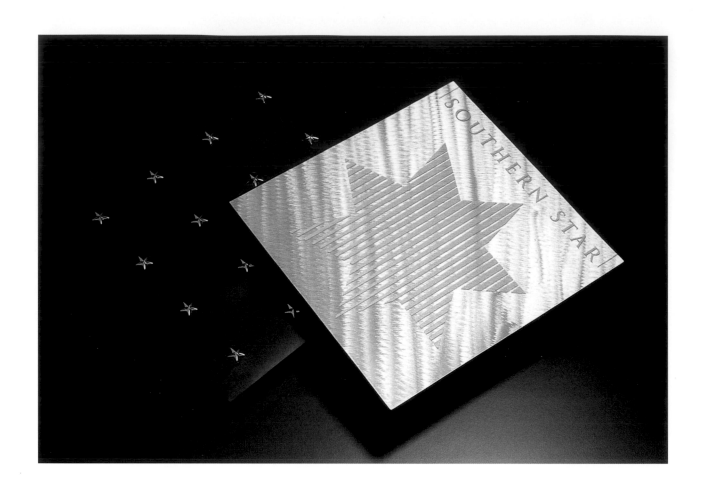

Project	Southern Star
Studio	Harcus Design
Art Director	Annette Harcus
Designer	Annette Harcus
Client	Southern Star

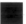

A limited edition catalogue folio for a film and television company, this project presents interesting materials in an unusual size, making a rich impression. The cover was silkscreened on metal. An attractive color combination and unusual elements amply compensate for the restricted palette.

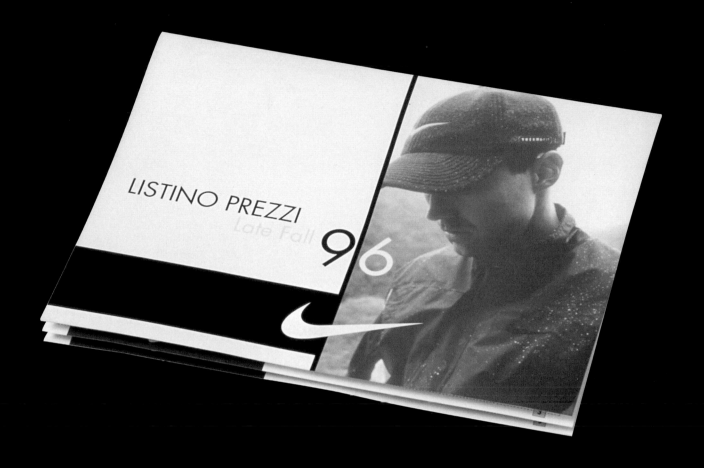

Project	Nike Price List Late Fall '96
Studio	Matite Giovanotte
Art Director	Ezio Massimo Arrigoni
Photographer	Nike File
Client	Nike Italy

This price list brochure, done in black only, is very effective. Part of Nike's European seasonal catalogues for footwear, apparel, and accessories, this piece had to look similar to others in its series, but also have its own individual look, and be economically produced.

Project	VideoCube
Studio	Sayles Graphic Design
Art Director	John Sayles
Designer	John Sayles
Client	ImMix

"Since this packaging program is used for shipping," the designer says, "there was no compelling reason to invest a lot of money in printing with multi-colored inks." Nonetheless, it has a high degree of visual interest, due in part to its bold graphic.

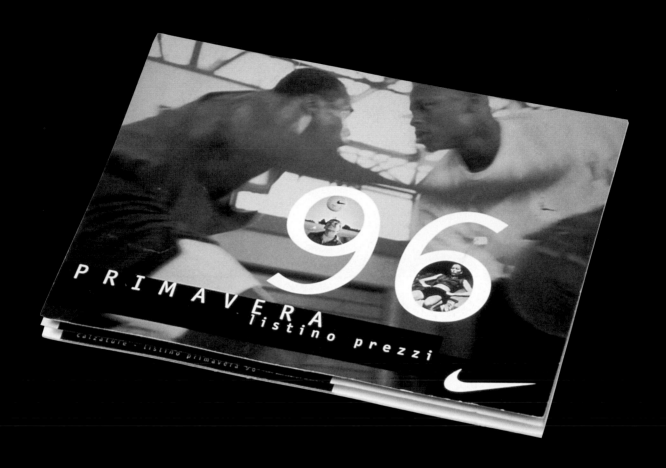

Project Nike Price List Spring '96
Studio Matite Giovanotte
Art Director Barbara Casadei
Photographer Nike File
Client Nike Italy

One of a series of catalogues created for Nike, this price list
brochure made very effective use of one color, in everything from
photographs to typography to use of halftone.

SYMBOL

(sign proper)

The symbol is a sign where the signifier is an arbitrary social convention. This includes almost all words and most other signifiers. Ferdinand de Saussure, one of the fathers of semiotics, objected to the word "symbol," insisting instead on the term "sign proper."

The word list on the left side of the chart, forming the "y" axis, is already a list of symbols because written words are arbitrary signifiers. Try to fill the symbols column with symbols other than those words.

INDEX

An index is a sign where there is a physical relationship (but not a physical resemblance) between the signifier and its referent. Smoke can be an index of fire; a fingerprint can be an index of a criminal, of criminality, or of criminal activity.

An index can be an especially powerful sign. The absence of physical depiction of the referent engages the imagination and can evoke a very strong reaction.

If this chart and booklet do nothing other than remind you to think about indices, it has accomplished something important.

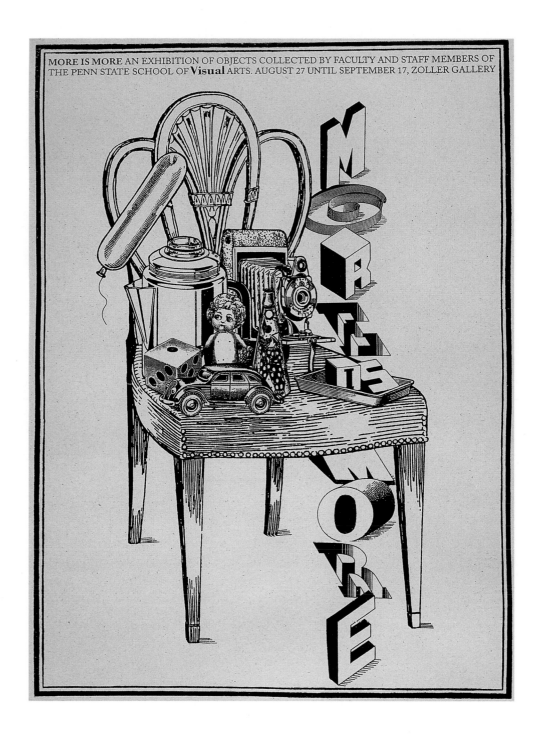

Project	More is More
Studio	Sommese Design
Art Director	Lanny Sommese
Designer	Lanny Sommese
Illustrator	Lanny Sommese
Client	Penn State School of Visual Arts

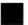

An antique camera, a doll, and a coffee percolator are just a few of the objects depicted on this poster for an exhibit of items collected by faculty and staff members of the Penn State School of Visual Arts. Black ink was used on tan stock to establish an appropriately nostalgic tone.

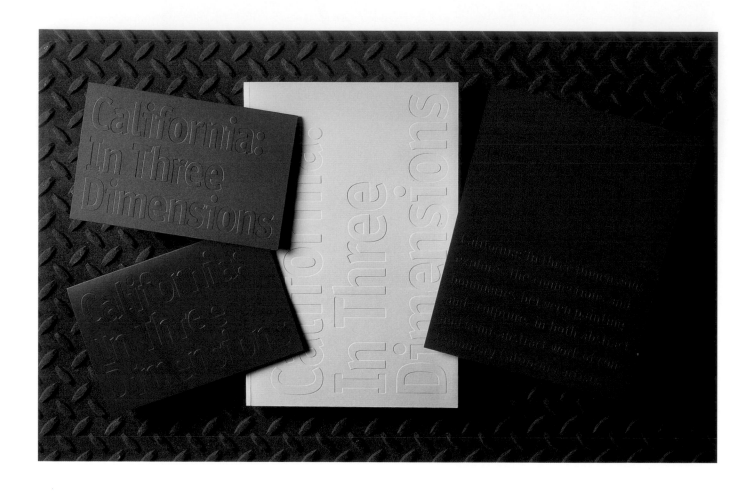

Project	California in 3 Dimensions Invitation
Studio	Mires Design, Inc.
Art Director	John Ball
Designers	John Ball and Deborah Hom
Client	California Center for the Arts, Escondido

The interplay of blind embossing with black type helped make this invitation especially distinctive. Each piece used a differently colored paper, achieving the illusion of a multi-colored project.

two colors

Project	Wine Label
Studio	Karl Design
Art Director	Andreas Karl
Designer	Andreas Karl
Photographer	Peter Komuczki
Illustrator	Andreas Karl
Client	Rheingauer Winzerverband

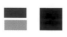 These witty labels are a perfect fit for the bottles chosen for this wine, and manage to look both contemporary and classic—an appealing, upscale image.

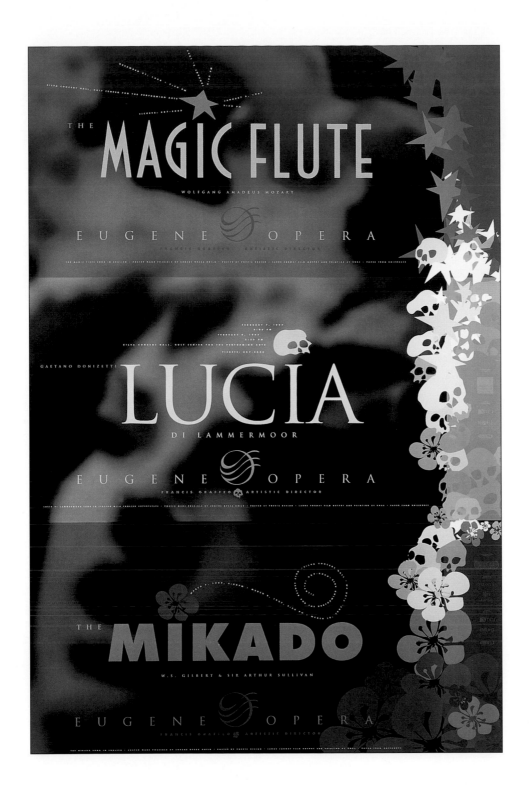

Project	Eugene Opera 96 / 97 Season Posters
Studio	Poppie Advertising Design
Art Director	Bill Poppie
Designer	Matt Tullis
Photographer	Stock
Illustrator	Matt Tullis
Client	Eugene Opera

This oversized poster is actually made up of three individual posters put together. Cleverly designed to control printing costs, the total presentation promotes the entire Eugene Opera season, and also reveals the full multi-colored image.

NOVETATS PRIMAVERA 1995

Nova carta d'Antoni Tàpies

Nous plats de temporada

Menú Degustació Nit 4.000 ptes.

i de nou, el jardí.

Roig Robí

Restaurant amb jardí

Sèneca 20, 08006 Barcelona. Tels. 218 92 22 - 217 97 38. Parking gratuït

CAMA-SEC PEBRÀS ALZINOIA ROURÓ
MOIXERNÓ ROSSINYOL VAQUETA PEU DE
RATA FREDOLIC FREDULUC NEGRET
CAMA DE PERDIU GIRGOLA LLENEGA
BLANCA PIXACÀ CARRERETA FALS MOIXERNÓ
ROVELLÓ ESCLATA-SANG VINADER ROVELLÓ DE
SOLELL PINETELL PINENC ROVELLÓ D'OBAGA REIG

La Cuina dels Bolets

LLENEGA NEGRE QUICOU MONJOLA PICORNELL
ORIOL BOLET D'OR SURENY LLENEGA NEGRE CIGRÓ
ROVIROL POLLANCRÓ ORELLANA ORELLES DE
BURRO VERDEROC SABATERA MOLLERIC GÍRGOLA
AGEROLA TASSA DE BRUC LLENGUA DE BOU
CANDELA DE BRUC ORELLA DE CONILL
LLORA BOLET DE TINTA CEP

OCTUBRE-NOVEMBRE 1996

Project	Roig Robí recipes
Studio	Sonsoles Llorens Graphic Design
Art Director	Sonsoles Llorens
Designer	Sonsoles Llorens
Photographer	Norberto Aliata (Mushrooms)
Client	Roig Robí Restaurant

This Barcelona restaurant printed recipes for its dishes on these handsomely designed cards. According to designer Sonsoles Llorens, her color choices were dictated by the desire to give the finished product a "more personal" look.

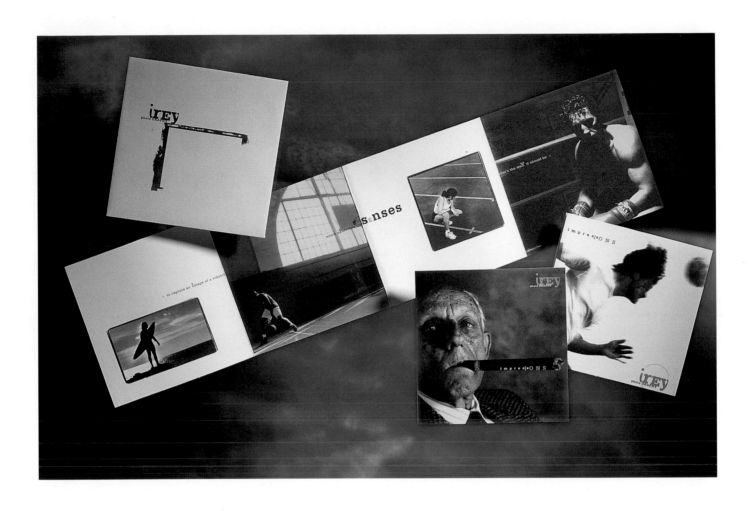

Project	Clark Irey Photo Promo
Studio	Ted Williams Design Group
Art Director	Tom K. Sieu
Designer	Tom K. Sieu
Photographer	Clark Irey
Client	Clark Irey

Creative use of a duotone palette resulted in this elegant and dramatic promotional mailer for a San Francisco photographer. The designer chose the duotone to "convey a certain mood of simplicity, representative of the photographer's view of the subjects shown in this promo."

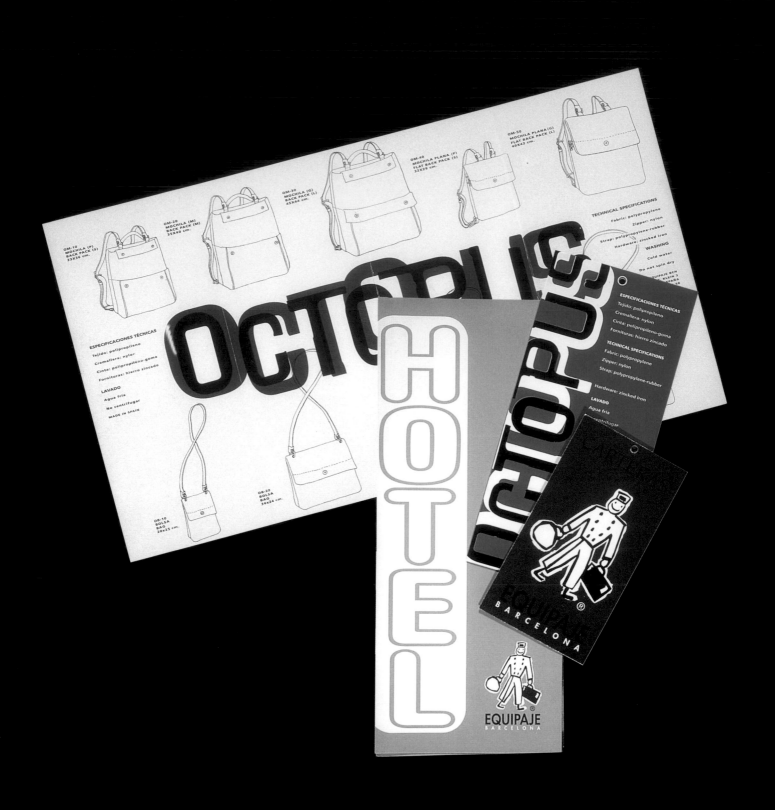

Project Equipaje BCN Octopus + Hotel Collections
Studio Sonsoles Llorens Graphic Design
Art Director Sonsoles Llorens
Designer Sonsoles Llorens
Photographer Ricardo Miras
Client Félix Preciado, Equipaje BCN

Mature designers know when two colors are enough.
For this collateral material for Equipaje, a luggage
manufacturer, two colors were all that was needed to
communicate the product's virtues.

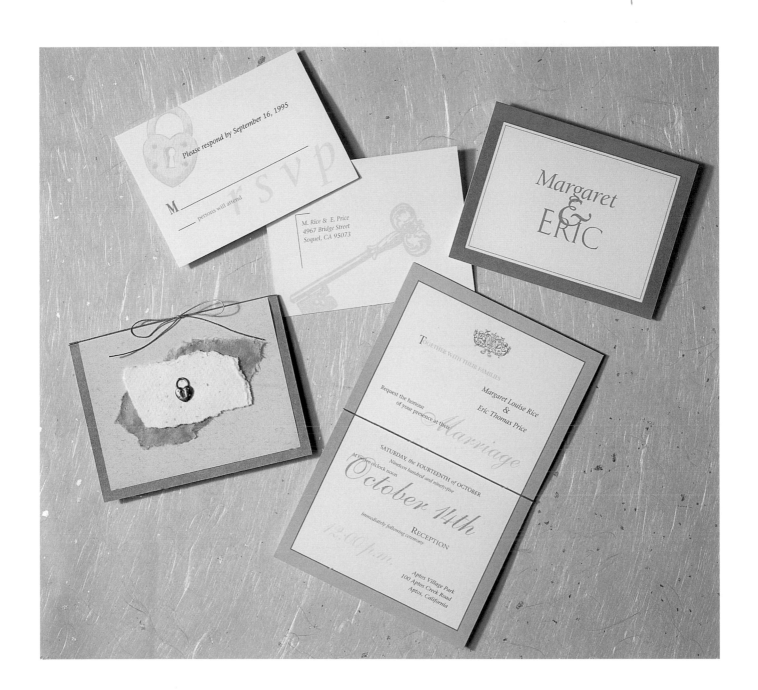

Project	Key to My Heart Wedding Invitation
Studio	Design Source
Art Director	Cari Johnson
Designer	Cari Johnson
Illustrator	Peter Costello
Client	Margaret and Eric Price

A combination of handmade and recycled papers with other materials, such as part of a heart-shaped locket, was used in this wedding invitation to especially charming effect. Color supports the design extremely well.

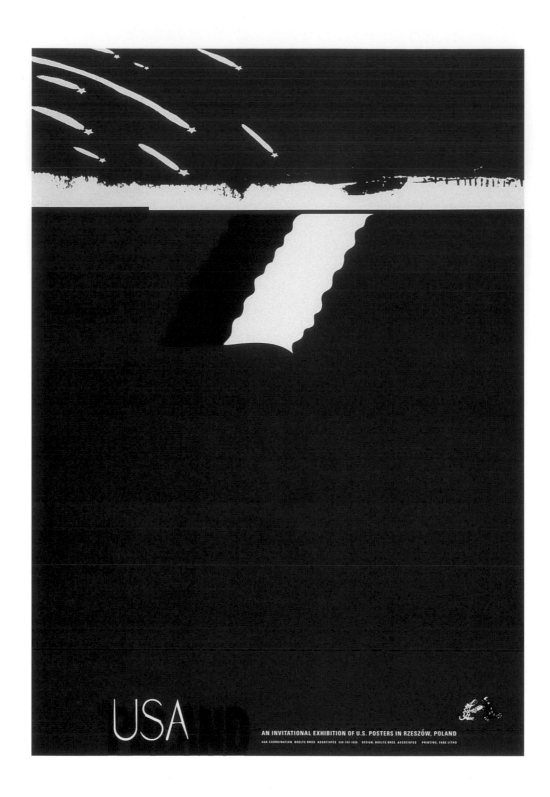

Project	USA in Poland Poster
Studio	Boelts Bros. Associates
Art Directors	Jackson Boelts and Eric Boelts
Designers	Eric Boelts and Jackson Boelts
Illustrator	Eric Boelts
Client	USA in Poland Poster Exhibition

Poland's national colors, red and white, combine with the red, white, and blue of the United States to create this eyecatching poster. In purely visual terms, this is an extraordinarily powerful image—no other color is needed.

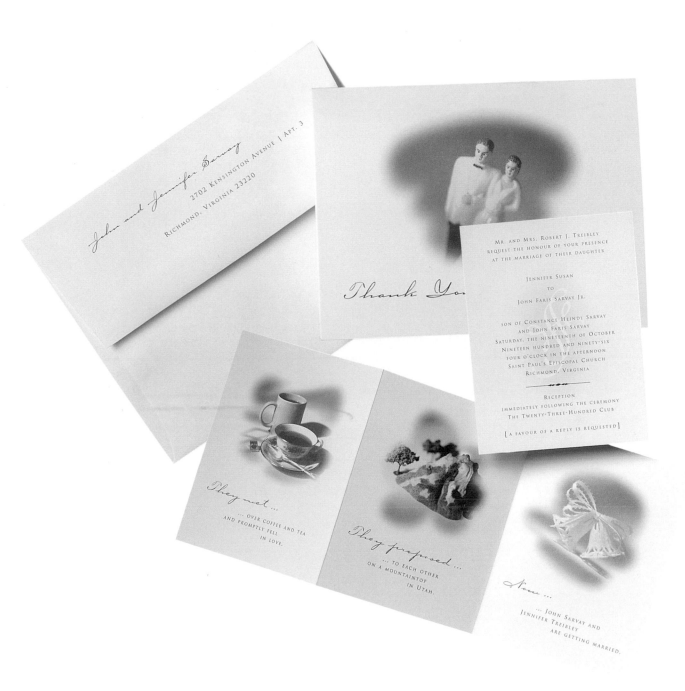

Project	Sarvay / Treibley Wedding Invitation
Studio	C. Benjamin Dacus
Art Director	C. Benjamin Dacus
Designer	C. Benjamin Dacus
Photographer	Kip Dawkins
Client	John Sarvay and Jennifer Treibley

"The mood we wanted to create was the main reason for selecting the colors," the designer of this attractive and unusual wedding invitation reports, adding, "Using two colors enabled us to make rich duotones as well as make the project affordable."

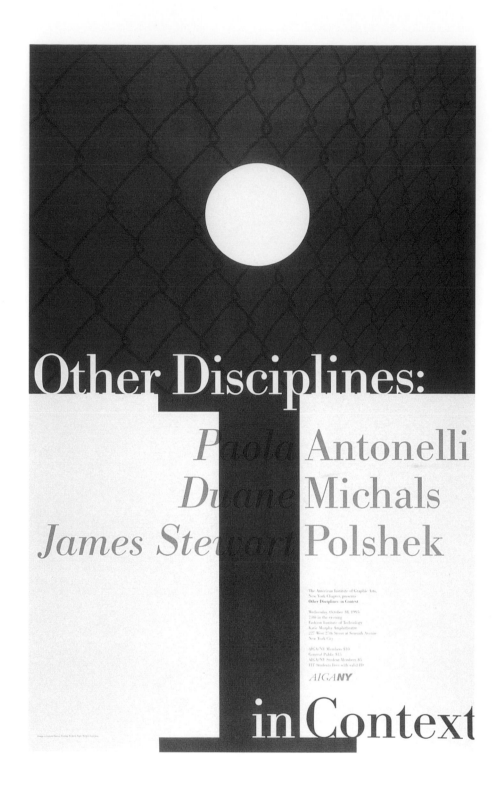

Project Other Disciplines Poster
Studio J. Graham Hanson Design
Designer J. Graham Hanson
Photographer J. Graham Hanson
Writer Leslie Adler
Client AIGA New York

This poster advertising an exhibit by a trio of artists made imaginative use of red and blue to create a memorable and compelling image. The white dot of the 'i' doubles as the sun.

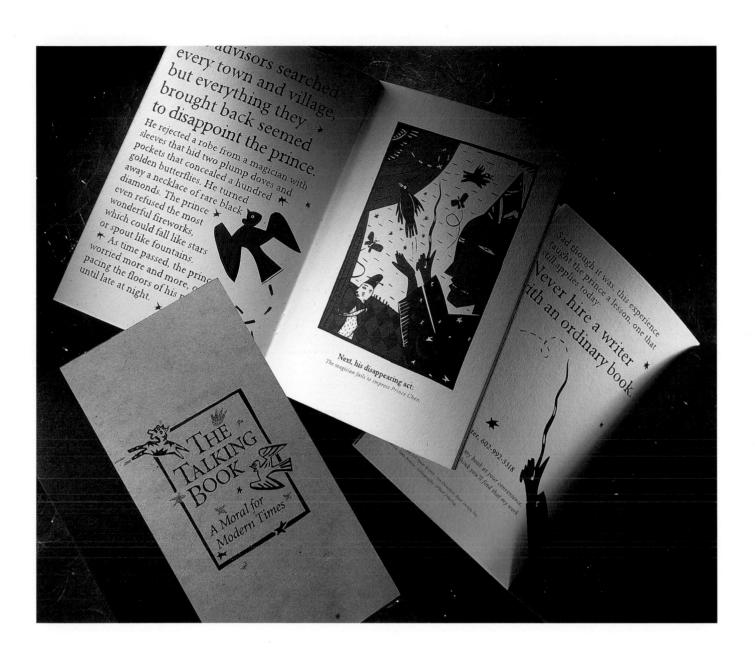

The Talking Book
A Moral for Modern Times

advisors searched
every town and village,
but everything they
brought back seemed
to disappoint the prince.

He rejected a robe from a magician with
sleeves that hid two plump doves and
pockets that concealed a hundred
golden butterflies. He turned
away a necklace of rare black
diamonds. The prince
even refused the most
wonderful fireworks,
which could fall like stars
or spout like fountains.
★ As time passed, the prince
worried more and more,
pacing the floors of his
until late at night.

Next, his disappearing act:
The magician fails to impress Prince Chen.

Sad though it was, this experience
taught the prince a lesson, one that
still applies today:
Never hire a writer
with an ordinary book.

Title	The Talking Book
Design Firm	Esser Design, Inc.
Art Director	Steve Esser
Designer	Jami Pomponi
Illustrator	John Nelson
Client	Jill Spear, copywriter

Every element of this miniature book is carefully thought out,
from the heavy cardboard stock used for the cover to the choice
of type and exquisite flyleaf of rice paper. The gold metallic ink
added to the cover by hand was a great finishing touch.

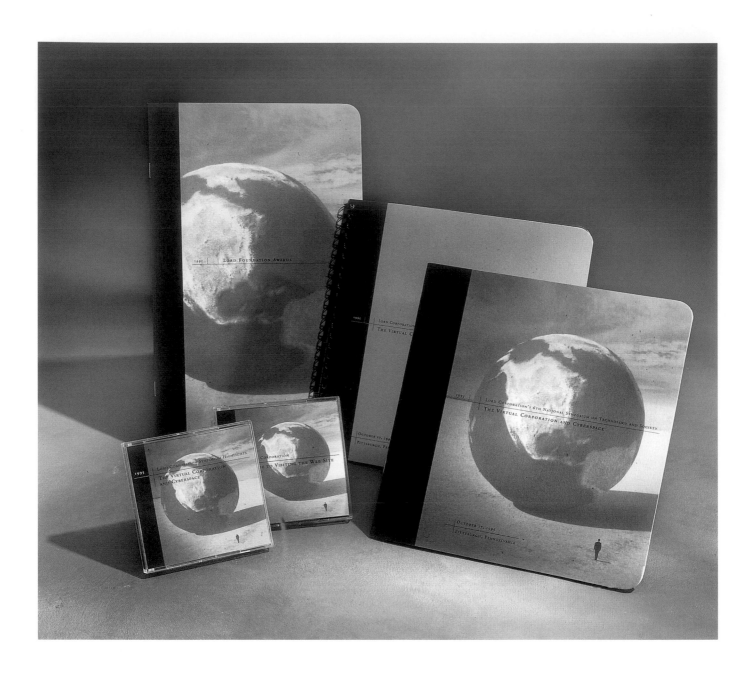

Project	The Virtual Corporation and Cyberspace
Studio	John Brady Design Consultants
Art Directors	John Brady and Mona MacDonald
Designers	Sharon Hamburger and Rick Madison
Photographer	Scott Morgan Inc.
Production	Sue Putt and Fran Brancato
Client	Lord Corporation

The designers of this kit say, "We felt the use of interactive media was necessary to effectively promote a symposium titled 'The Virtual Corporation and Cyberspace.' By limiting the design to two colors, we allowed for the production of an interactive diskette and web site."

BOSNIA

Project Bosnia
Studio Cedomir Kostovic
Art Director Cedomir Kostovic
Designer Cedomir Kostovic
Silkscreen Print Ken Daley
Illustrator Cedomir Kostovic
Client Art and Design Department SMSU

The violet shadow was an inspired touch for this poster,
adding subtlety and visual interest. The colors were selected
to emphasize the beauty of the instrument, while making
an effective contrast with the political statement.

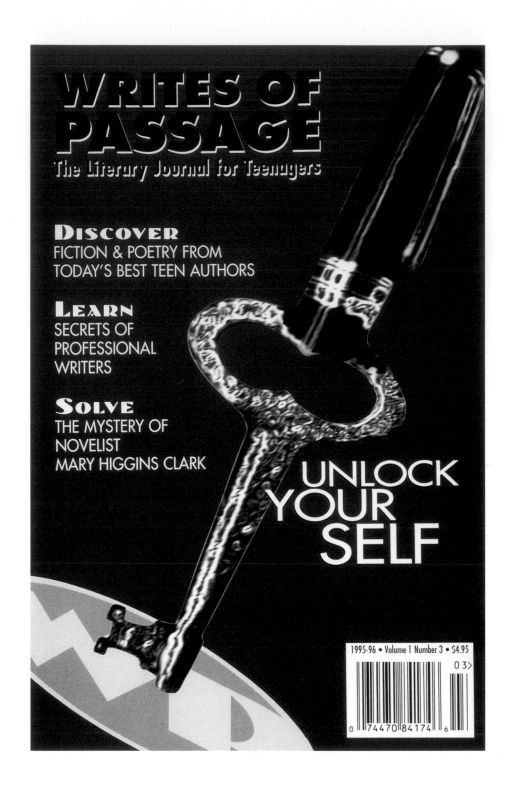

Project Writes of Passage Vol. 1, No. 3
Studio Michael C. Wang
Art Director Michael C. Wang
Client Writes of Passage

For this journal, published by a nonprofit educational
organization, a strong, bright color was chosen to contrast
with the black. Using screens and shades, the designer
was able to stretch a limited palette.

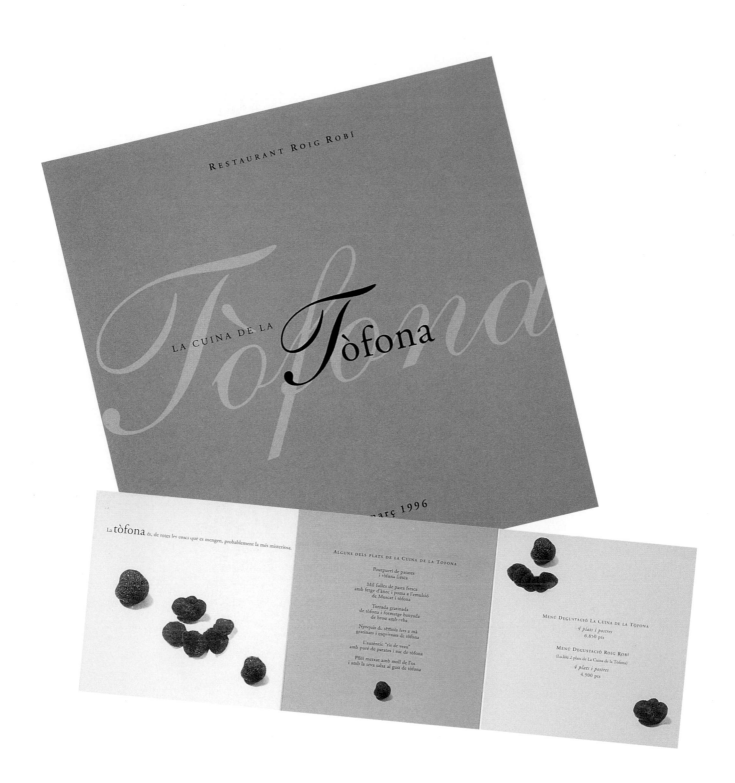

Project	La Cuina De La Tofona
Studio	Sonsoles Llorens Graphic Design
Art Director	Sonsoles Llorens
Designer	Sonsoles Llorens
Photographer	Rafael Vargas
Client	Roig Robí Restaurant

A Barcelona restaurant, Roig Robí, keeps in touch with customers with this elegant mailer, in which two colors are used to create a look both high-quality and austere, reflecting a special menu.

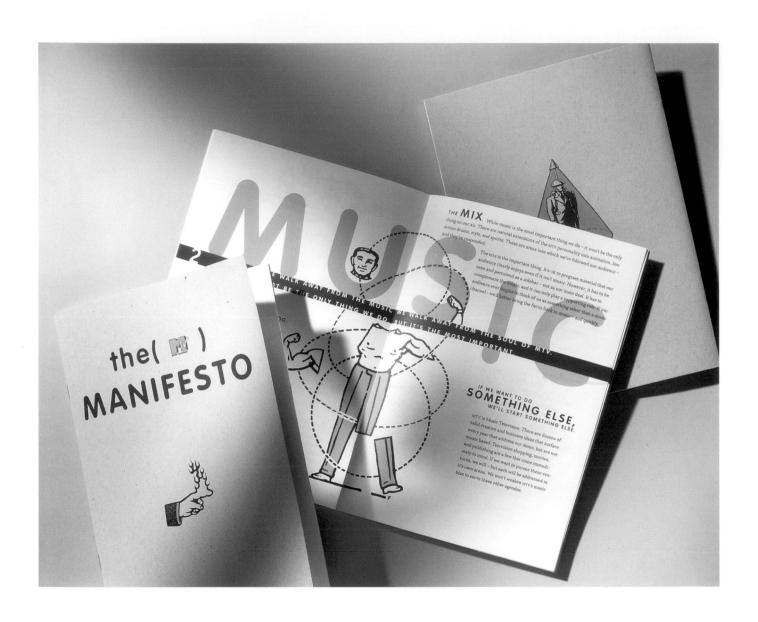

Project The MTV Manifesto
Studio Corey McPherson Nash
Art Directors Michael McPherson and Tom Corey
Designer Michael McPherson
Illustrator Mark S. Fisher
Client MTV

The graphics and colors used in this document give it just the
right informality and daring. The cover stock and the text stock
are in different colors, which adds flair to the simple layout.

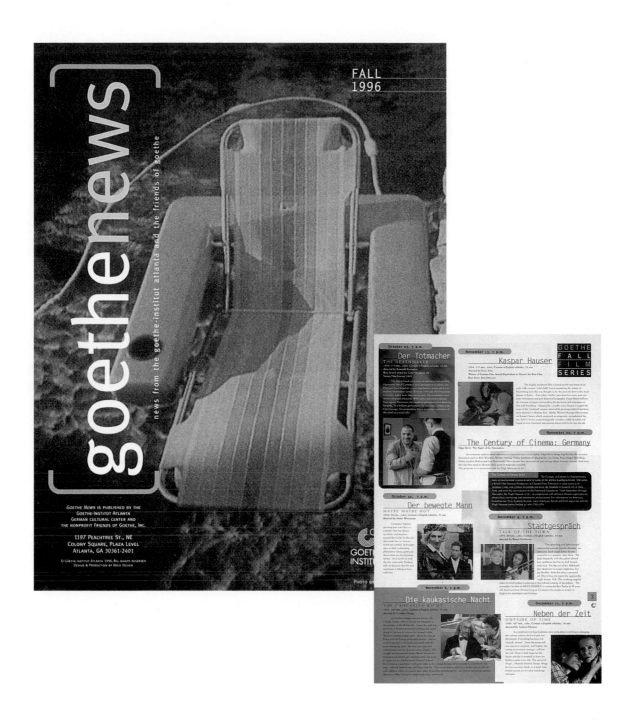

Project	Goethe News
Studio	Belfi Design
Art Director	Matt Belfi
Designer	Matt Belfi
Client	Goethe Institut

Created for a nonprofit cultural institution, this newsletter makes extensive and very effective use of halftone. Its layout is attractive, rendering a large amount of information simple and readable.

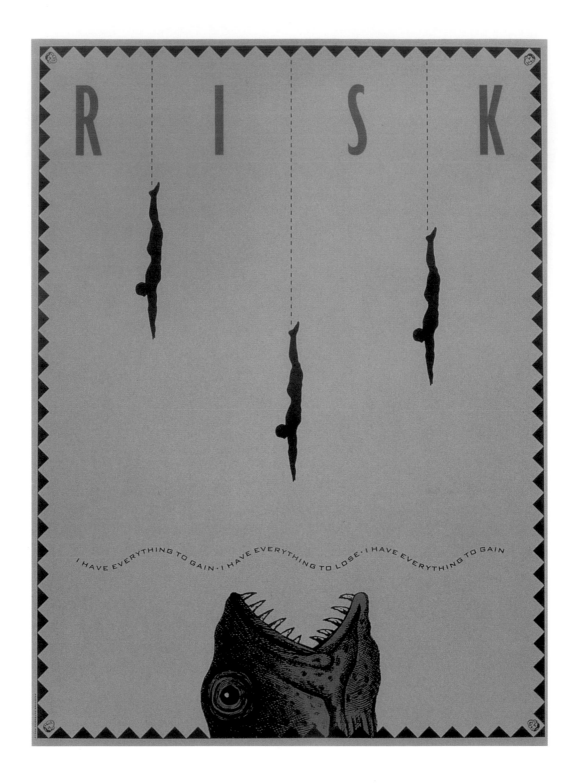

Project	Risk
Studio	Scorsone / Drueding
Art Directors	Joe Scorsone and Alice Drueding
Designers	Joe Scorsone and Alice Drueding
Client	Scorsone / Drueding

 This poster captures attention by the exquisitely effective use it makes of the paper on which it is printed. The simple graphics make it easy and fun to read the slightly unsettling story they tell.

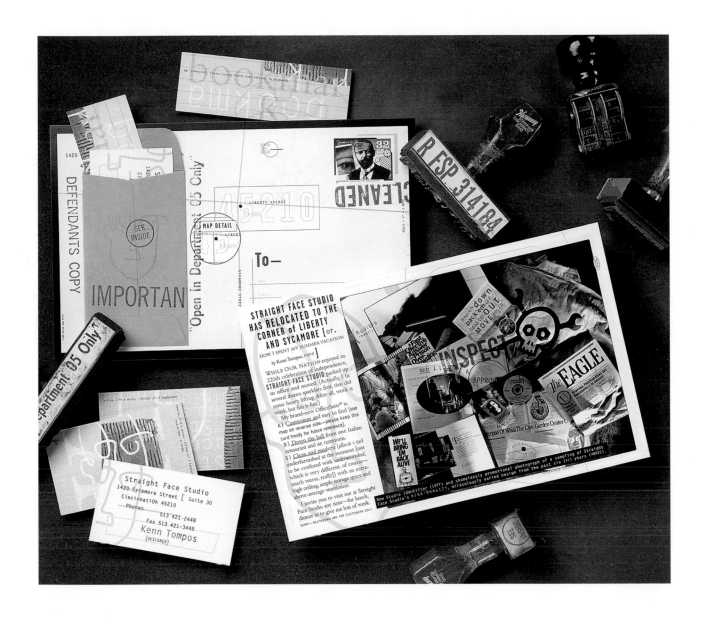

Project — Straight Face Studio Moving Announcement
Studio — Straight Face Studio
Art Director — Kenn Tompos
Photographer — Erik Von Fischer / blink
Client — Straight Face Studio

This moving announcement was printed in black and in Pantone 458. The background is a screen of the second color. The red rubber stamp adds a 'free' third color. The addition of the manila envelope results in an unexpected solution.

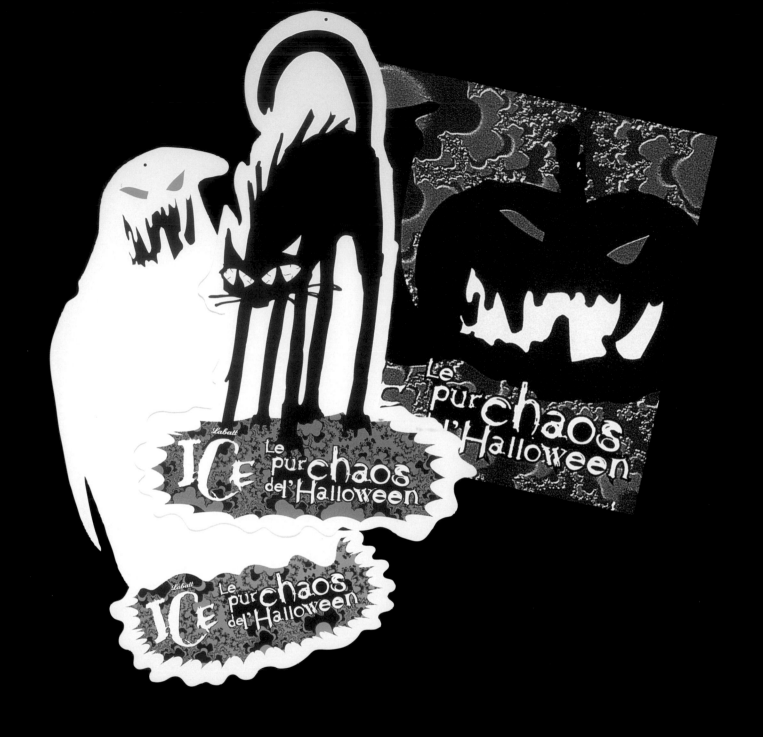

Project	Labatt Ice Beer Halloween Promo
Studio	Tarzan Communications
Art Directors	George Fok and Daniel Fortin
Designers	George Fok and Marc Serre
Illustrator	George Fok
Client	Labatt Brewing Company

Fluorescent color gives this project a "glow-in-the-dark" quality appropriate for Halloween. The diecuts result in fun and appropriate shapes, and the white of the paper itself is utilized effectively. A lot of detail provides the finishing touch.

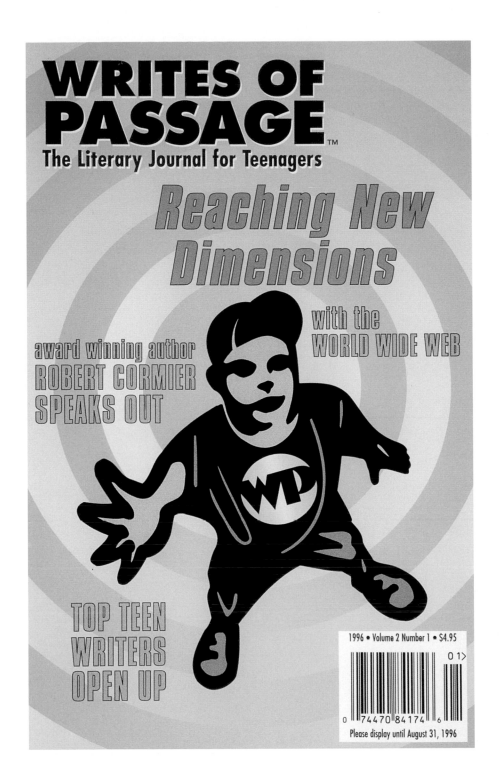

Project Writes of Passage Vol. 2, No. 1
Studio Michael C. Wang
Art Director Michael C. Wang
Illustrator Michael C. Wang
Client Writes of Passage

For this journal, published by a nonprofit educational organization, a strong, bright color was chosen to contrast with the black. Using screens and shades, the designer was able to stretch a limited palette.

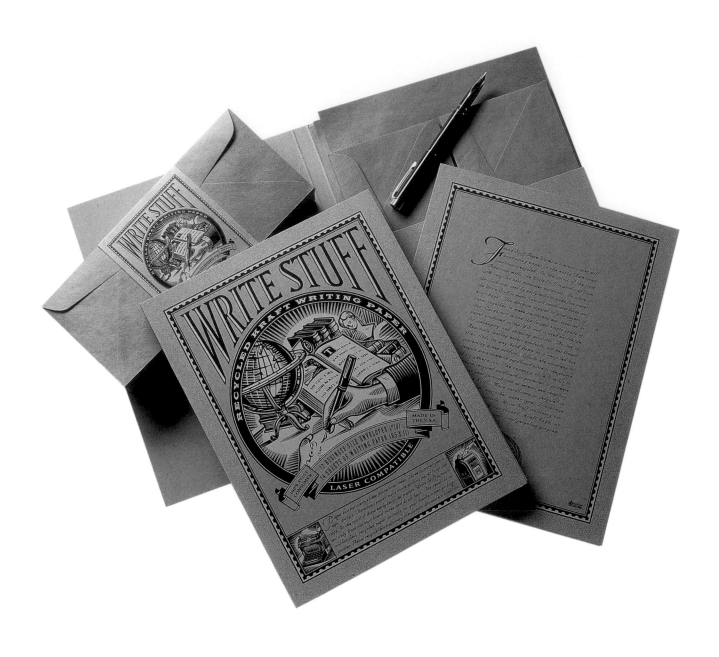

Project	Write Stuff Stationery Packaging
Studio	Mires Design, Inc.
Art Director	Jose Serrano
Designers	Jose Serrano and Miguel Perez
Illustrator	Tracy Sabin
Client	Green Field Paper Company

The paper came first for this project. The fact that it was recycled, the designers felt, called for limited use of color. The restricted color palette, in turn, echoed the simplicity of the product.

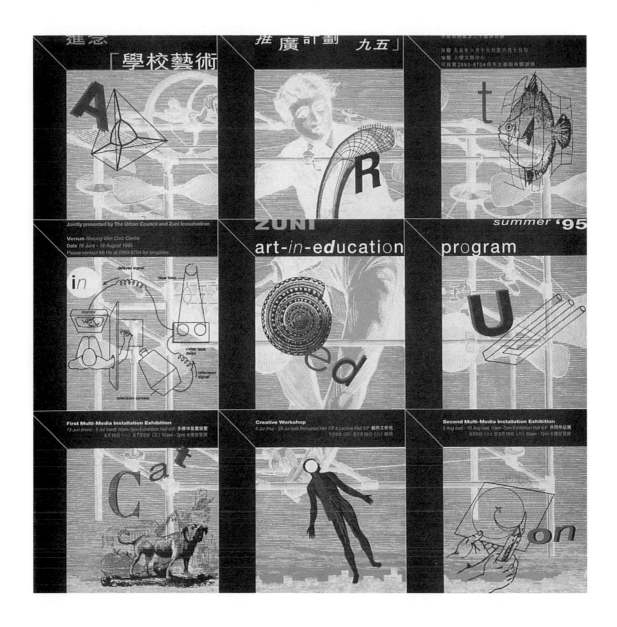

Project Art-in-education program summer '95
Studio Kan & Lau Design Consultants
Art Director Freeman Lau Siu Hong
Designers Freeman Lau Siu Hong and Patrick Fung Kai Bong
Client Zuni Icosahedron

This poster is both very complicated and very simple. It
makes great use of color and gives an interesting treatment to its
purple illustrations, with some printed in purple and some reverse
printed from orange.

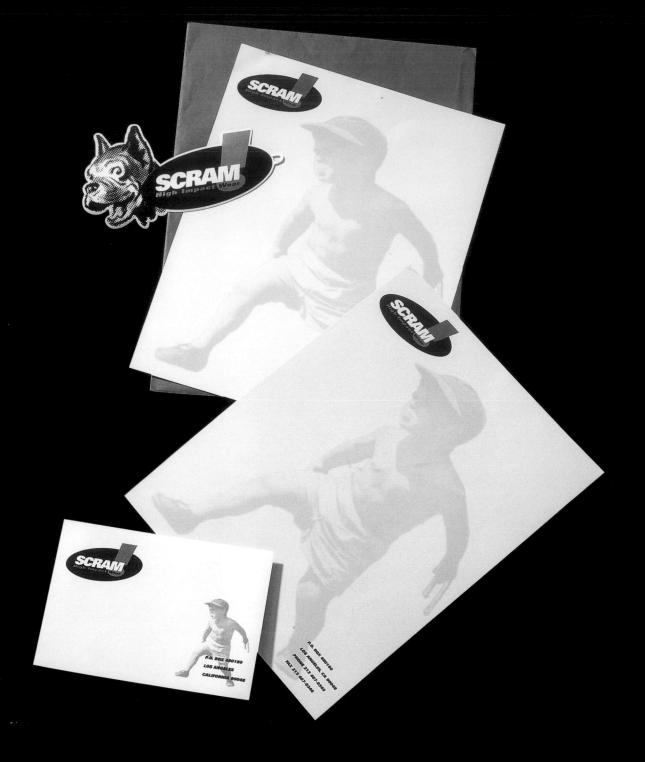

Project	Scram Stationery
Studio	BRD Design
Art Director	Peter King Robbins
Designer	Peter King Robbins
Client	Scram

The bold colors used in this stationery system were combined in such a way that they definitely attract attention. Correspondence received on this witty and fun letterhead would surely be read immediately.

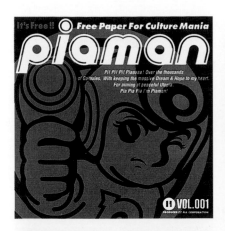

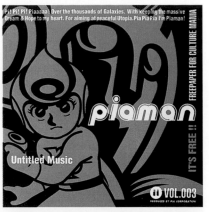

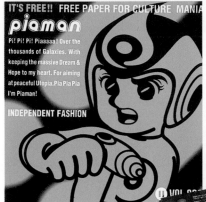

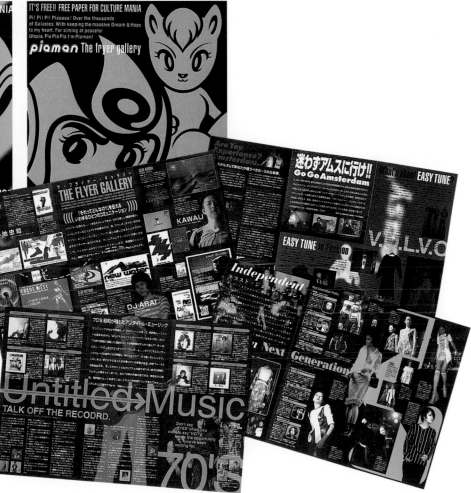

Project Piaman 1, 2, 3, 4 (Free Paper)
Studio Kirima Design Office
Art Director Harumi Kirima
Designer Harumi Kirima
Client Pia Corporation

A series of small fold-out brochures with a very contemporary look
and nice layout, this project combines a different bright, bold color
with black in each piece, for a total effect of great richness.

The mailer reads:

Vote, or shut up

bitch, moan, groan, whine, curse, complain, grouch, grumble, gripe, reject, refuse, pout, procrastinate, postpone, neglect, ignore, deplore, denounce, defend.

It's time to stop talking and do something. Like participate. And vote.

The annual election of the communicating arts group board of directors will be held thursday november 19 at tomato's (31 sports arena blvd). Talk starts at 6. Food (good italian stuff) at 7. Guest speaker bob kwait (award-winning zoo guy) at 7:45. Election at 8:15. Members pay $12. Non-members $15. (Please make a reservation and don't show or be billed.) If you can't make it then (at least) send in the proxy ballot. Mark 3 choices or write in some different ones:

○ frank cleaver (vp fine arts stuff) ○ rebecca debreau (graphic design, m.c.w.e.)

○ diane ditucci (sales, arts and crafts press) ○ elyce ellington (graphics manager, m.c.w.e.)

○ laura koonce-jose (computer production quorum) ○ linda lampman (art director, lambesis communications) ○ tom okerlund (copywriter/art director, spis-tv) ○ someone (anyone)

else: _____. Sign your name here _____ and mail to cag (3108 5th ave suite f san diego 92103) by november 17 or fax (295-3822) by november 19.

Project Vote Mailer
Studio Mires Design, Inc.
Art Director John Ball
Designer John Ball
Client Communication Arts Group

In this mailer, done pro bono, the bold "teaser" message in big, red type gets right to the point. There is a nice interplay between the red type and the bulk of the information, printed in smaller black type.

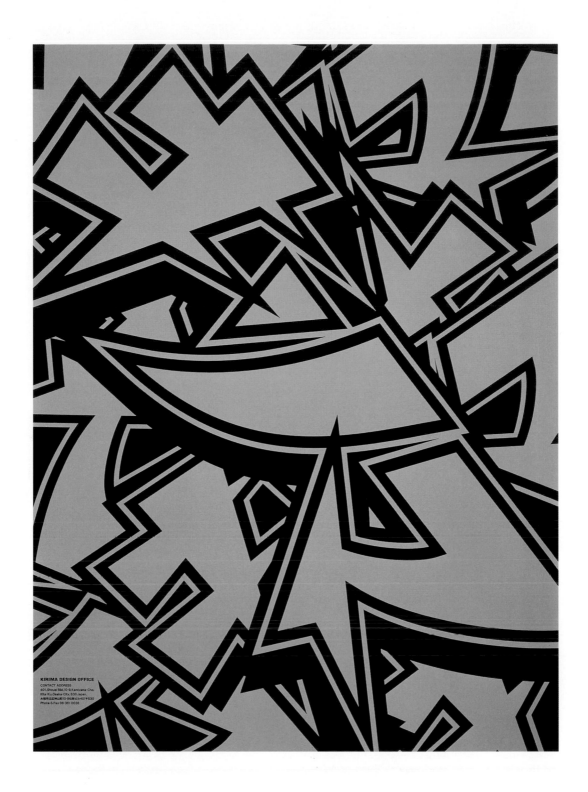

KIRIMA DESIGN OFFICE
CONTACT ADDRESS
401,Shouei Bld,10-9,Kamiyama-Cho,
Kita-Ku,Osaka-City, 630,Japan,
大阪市北区神山町10-9ショウエイビル401 〒530
Phone & Fax 06-361-0036

Project	Kirima Design Office Poster
Studio	Kirima Design Office
Art Director	Harumi Kirima
Designer	Harumi Kirima
Client	Kirima Design Office

This poster promotes a design studio with a bold abstraction, and makes extremely effective use of color. Its large size and inherent graphic interest draw the eye across long distances.

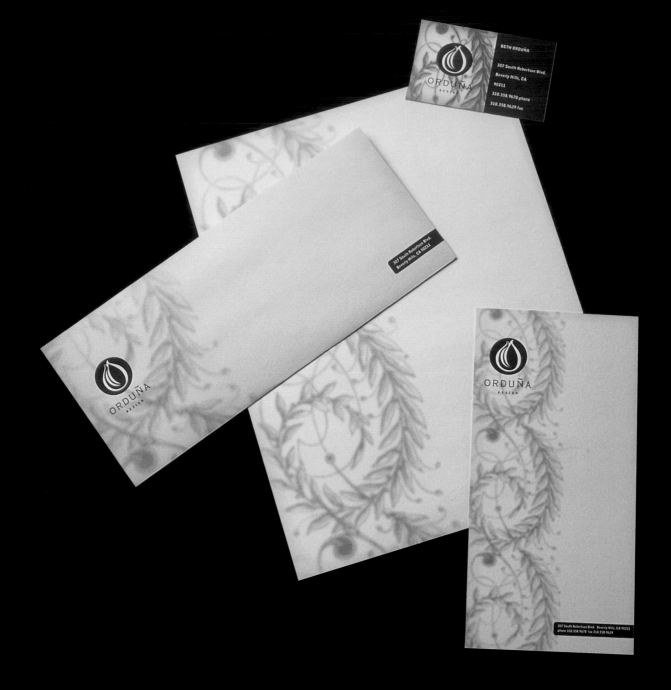

Project	Orduna Design Stationery
Studio	BRD Design
Art Director	Peter King Robbins
Designer	Peter King Robbins
Client	Orduna Designs

This letterhead makes exceptionally elegant use of halftone, using it to create an attractive colored background. The combination of the classy logo with sleek and classic type works to great advantage.

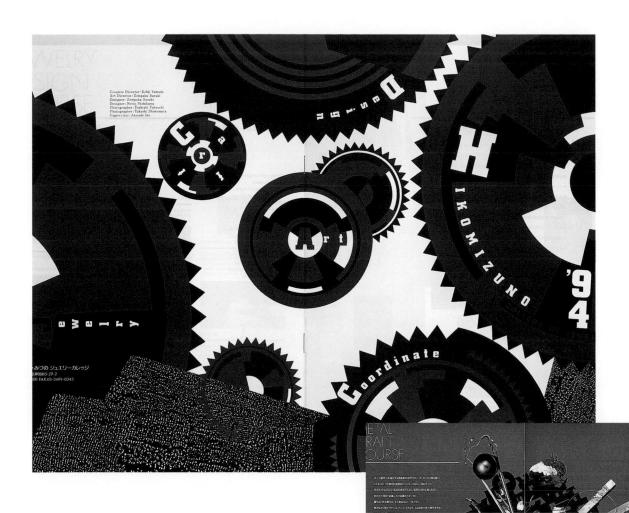

Project	Hikomizuno College of Jewelry '94
Studio	B-BI Studio Inc.
Creative Director	Koji Yamada
Art Director	Zempaku Suzuki
Designers	Zempaku Suzuki and Norio Nishikawa
Photographers	Toshiaki Takeuchi and Takashi Shimomura
Client	Hikomizuno College of Jewelry

Color can give a project undeniable power, as this catalog shows. The graphics are as bold as the color used in this piece. The over-sized format adds to the impact. A different color was used for each section, for a more expensive look overall.

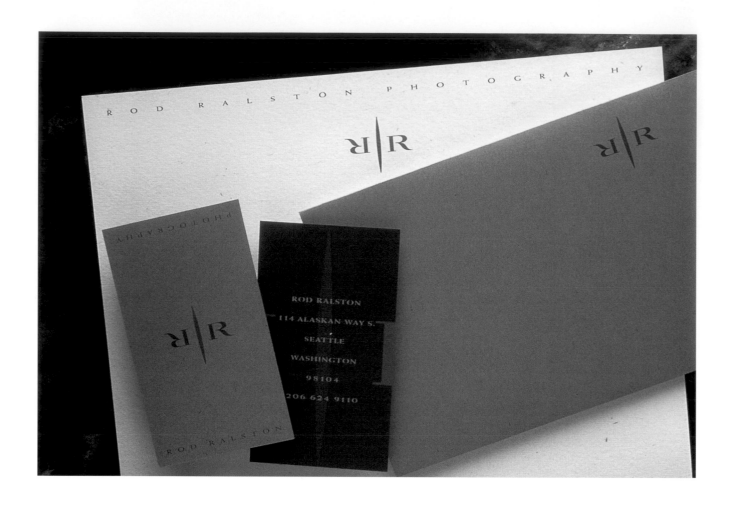

Project	Rod Ralston Stationery Program
Studio	Hornall Anderson Design Works, Inc.
Art Director	Jack Anderson
Designers	Jack Anderson, Julie Keenan, Mary Chin Hutchison
Calligrapher	George Tanagi
Client	Rod Ralston Photography

The ochre color of the paper used in this stationery was an unusual choice, but very effective in combination with the green and burgundy colors applied to it. This letterhead is unmistakably *designed*, for an upscale, consciously image-oriented look.

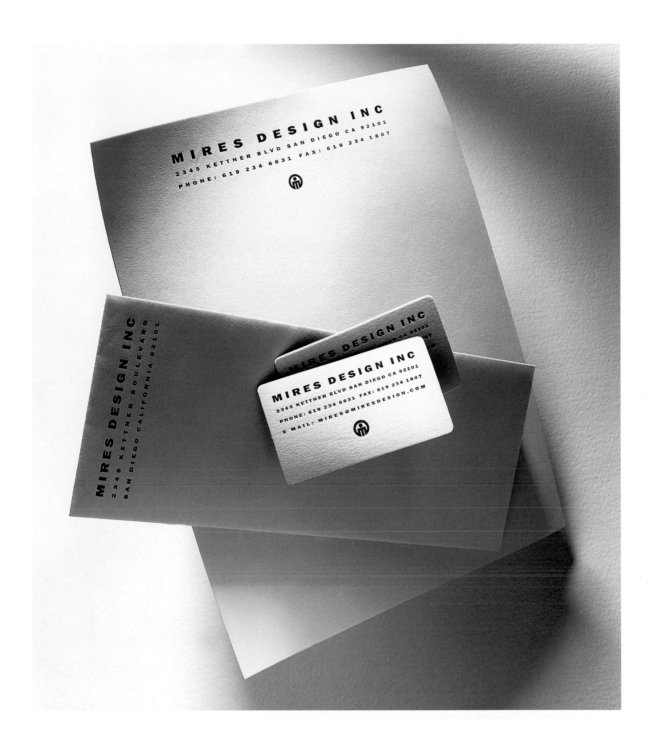

Project	Mires Design Letterhead
Studio	Mires Design, Inc.
Art Director	John Ball
Designers	John Ball, Miguel Perez
Client	Mires Design, Inc.

For their studio letterhead, the designers report, "We wanted a bold, classic look that would not go out of style. Two colors were all that we needed to achieve it."

73

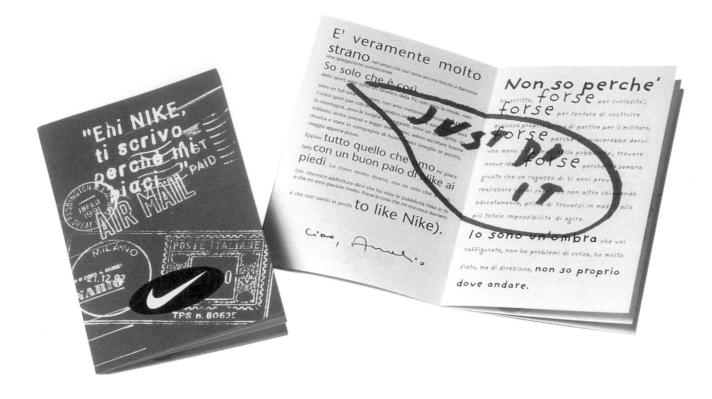

Project "EHI Nike"
Studio Matite Giovanotte
Art Director Barbara Longiardi
Client Nike Italy

This brochure, created for employees at Nike Italy as a
Christmas present, makes festive and informal use of two colors.
The contemporary layout adds interest.

Project	"War" panel from triptych
Studio	Atelier Tadeusz Piechura
Art Director	Tadeusz Piechura
Designer	Tadeusz Piechura
Photographer	Tadeusz Piechura
Client	Atelier Tadeusz Piechura

This poster must be described, since its special features can't all be
captured on film. After printing, the designer created numerous wrinkles
in this piece, so that it acquired a unique "embossed" quality.

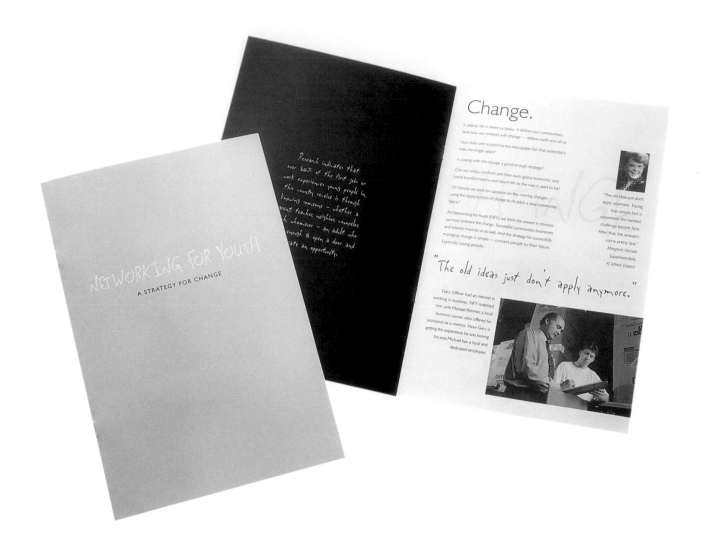

Project Networking for Youth Brochure
Studio Inovar, Inc.
Art Director Henry Abel
Designer Henry Abel
Photographer Peter Chapman
Client Networking for Youth

Black and PMS 4545 were used for this fundraising brochure. The second color was applied in just the right amount; decorative and memorable, it made a real difference in the total presentation. The overall look is appropriately frugal, professional, and youth-oriented.

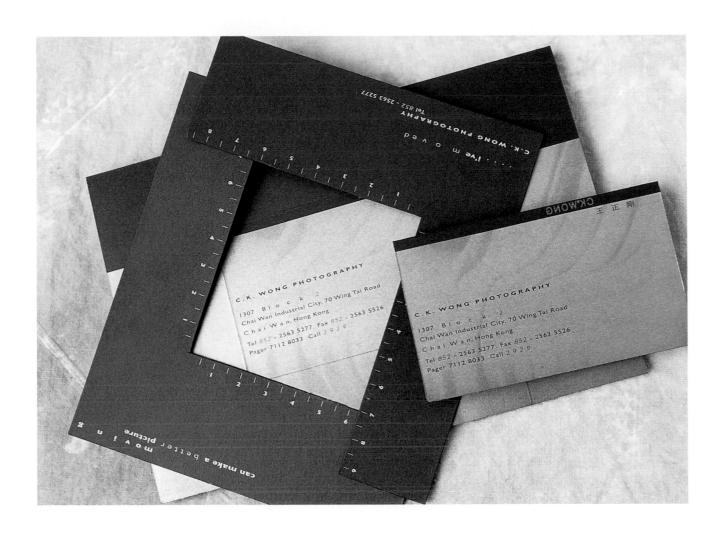

Project	C. K. Wong—Moving Announcement
Studio	Kan & Lau Design Consultants
Art Directors	Kan Tai-keung and Eddy Yu Chi Kong
Designers	Eddy Yu Chi Kong and Patrick Fung Kai Bong
Photographer	C. K. Wong Photography

The color palette couldn't be more appropriate for this elegant and deceptively simple photographer's moving announcement, with its removable business card framed by cropping tools.

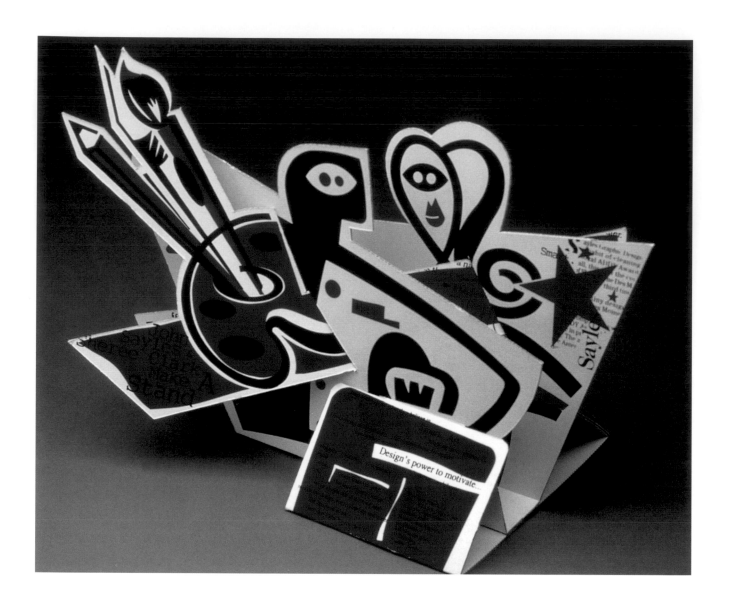

Project	John Sayles and Sheree Clark Make A Stand
Studio	Sayles Graphic Design
Art Director	John Sayles
Designer	John Sayles
Illustrator	John Sayles
Client	Wichita AIGA

"Since the printing for this nonprofit event was donated," the designer reports, "a limited color palette was used out of regard for the vendors who were supplying their time and materials."

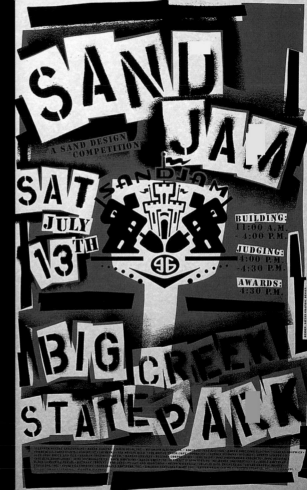

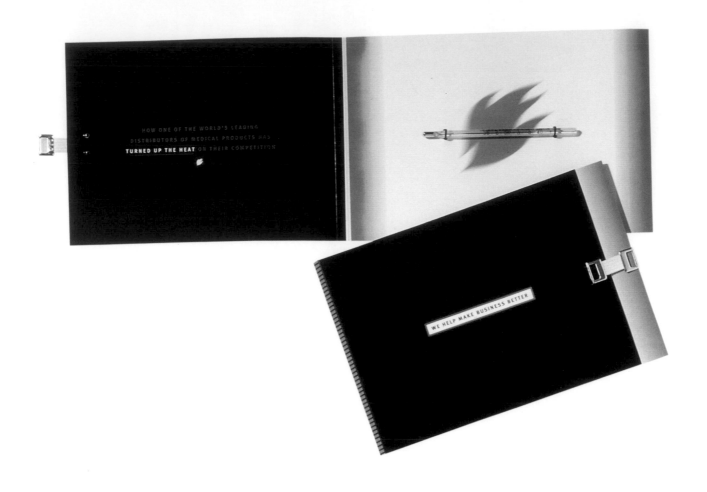

Project MasterPack 'Thermometer' Mailer
Studio Harcus Design
Art Director Annette Harcus
Designer Annette Harcus
Client MasterPack International

This elegant promotional mailer makes great use of color.
Its graceful flame graphic, appearing on the front cover and
repeated inside, and witty copy all contribute to its appeal.

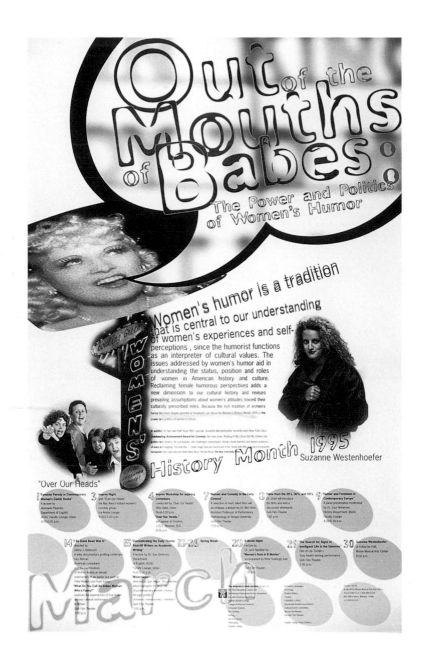

Project	"Out of the Mouths of Babes" Poster
Studio	Todd Childers Graphic Design
Art Director	Todd Childers
Designer	Todd Childers
Photographer	from comedian's press kit
Type Design	Todd Childers
Client	Bowling Green State University Women's Studies Department

This witty poster makes reference to comic books and their production process to advertise events celebrating women's humor. The designer mixed process colors to give his work a broad range of tones.

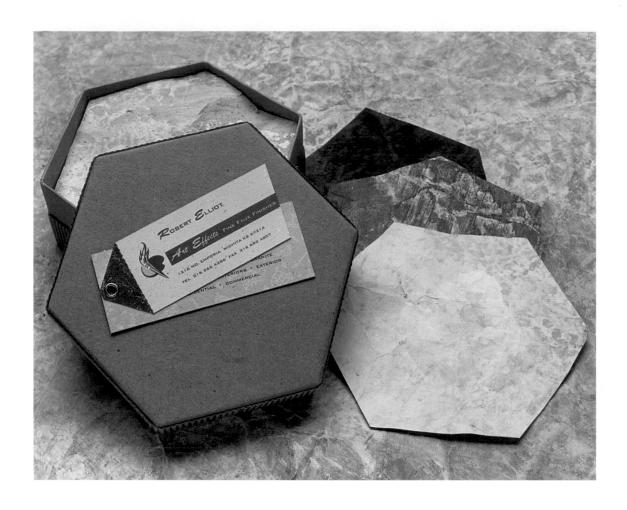

Project	Art Effects Direct Mail
Studio	Insight Design Communications
Art Directors	Sherrie and Tracy Holdeman
Designers	Sherrie and Tracy Holdeman
Photographer	Digital Rock Island Studio
Illustrators	Sherrie and Tracy Holdeman
Client	Art Effects

Two colors combine well with each other and with the paper used in these tags, designed to be affixed to a direct mail piece. The layered construction and use of screen printing effortlessly suggest the nature of the business.

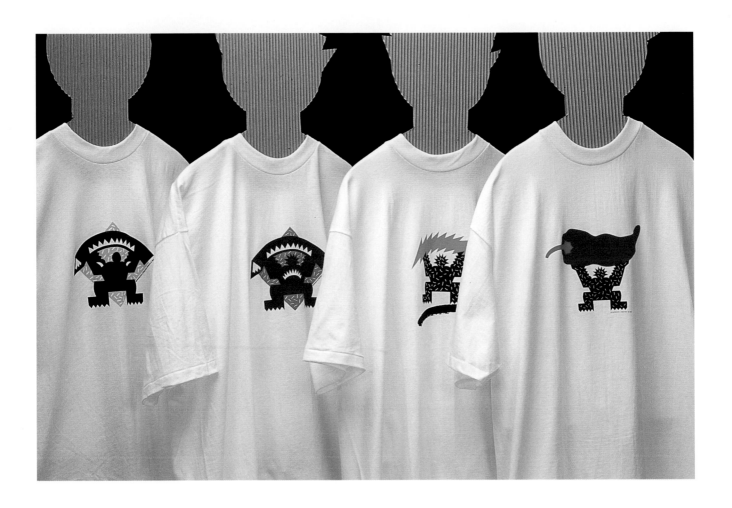

Project	Shimokochi/Reeves Marketing Man T-Shirts
Studio	Shimokochi/Reeves
Art Directors	Mamoru Shimokochi, Anne Reeves
Designers	Mamoru Shimokochi, Anne Reeves
Photographer	Mark Shimokochi
Illustrator	Mamoru Shimokochi
Client	Shimokochi/Reeves

 With the exception of the one showing a figure lifting a red chili pepper, these promotional T-shirts were silkscreened in two colors, each contrasting black with a bright, appealing second color.

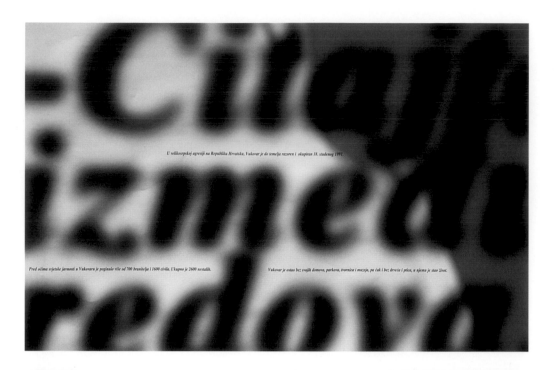

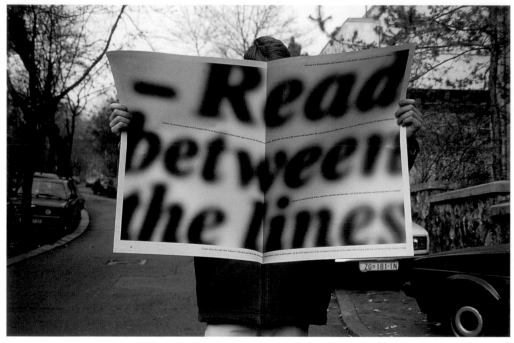

Project	Read Between the Lines
Studio	Studio International
Art Director	Boris Ljubicic
Designer	Boris Ljubicic
Photographer	Boris Ljubicic
Illustrator	Boris Ljubicic
Client	Croatia

The power of type is clearly demonstrated in this forceful political statement from troubled Croatia. A message is printed in small type between larger lines of type in this arresting image. The black and cyan colors chosen for this piece give it exactly the right kind of gravity.

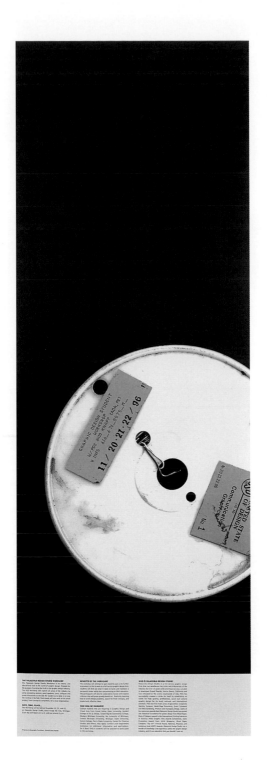

Project	Student Workshop
Studio	Palazzolo Design Studio
Art Directors	Gregg Palazzolo, Troy Gough, Signe Endersen, Marci Montgomery
Designer	Gregg Palazzolo
Photographer	Umax Scanner
Client	Palazzolo Design Studio Graphic Design Student Workshop

A touch of the orangish yellow familiar from school buses goes a long way in this pleasing poster, giving it maximum impact. Nice use of halftone rounds out this project, created in what the designers refer to as "the world of Photoshop."

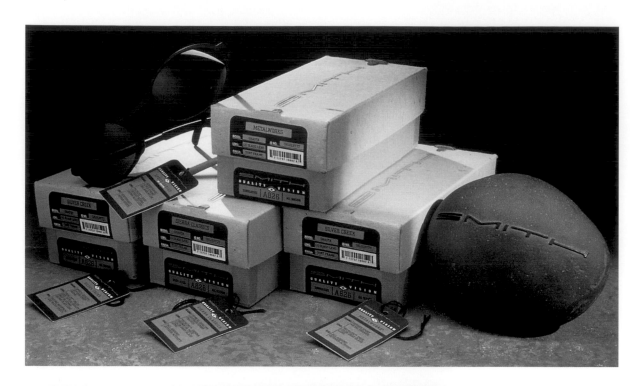

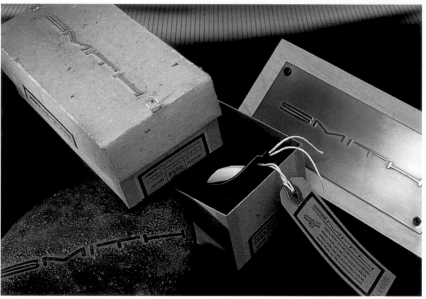

Project	Smith Sport Optics Sunglasses Packaging
Studio	Hornall Anderson Design Works, Inc.
Art Director	Jack Anderson
Designers	Jack Anderson and David Bates
Client	Smith Sport Optics, Inc.

 "A limited color palette was used to give this packaging a more honest and natural feel," the designers report, "especially when applied to the Kraft box stock."

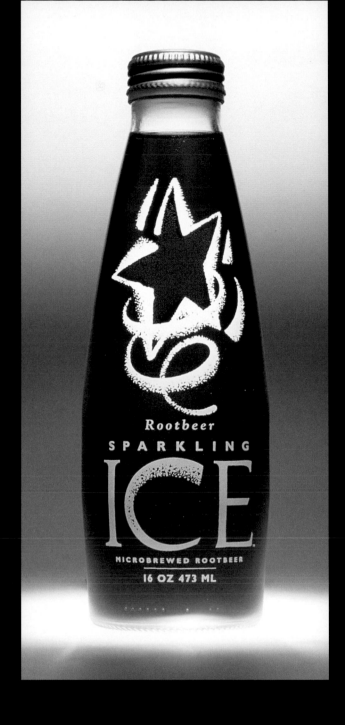

Project	Talking Rain Sparkling Rootbeer Bottle Packaging
Studio	Hornall Anderson Design Works, Inc.
Art Director	Jack Anderson
Designers	Jack Anderson, Jana Nishi
Illustrator	Julia LaPine
Client	Talking Rain

The designers chose the black and brown color combination for this bottle as a means of matching the container with its contents—in this instance, root beer.

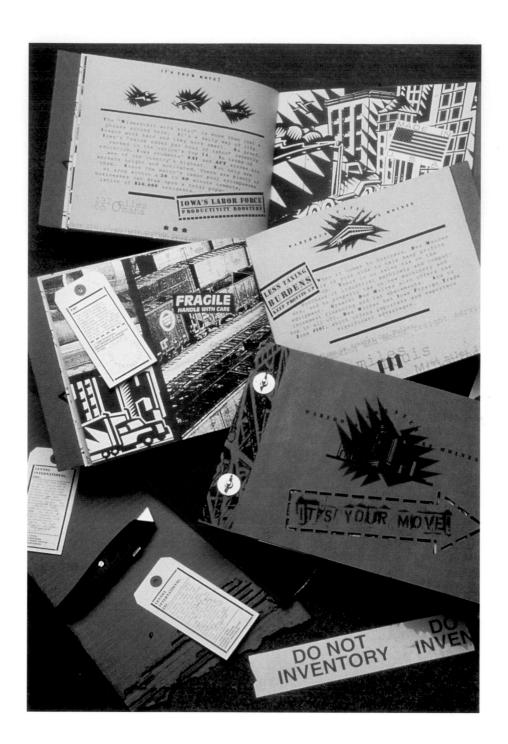

Project	Warehouse Greater Des Moines
Studio	Sayles Graphic Design
Art Director	John Sayles
Designers	John Sayles and Jennifer Elliott
Illustrator	John Sayles
Client	Greater Des Moines Chamber of Commerce

"The audience for this piece is warehouse operations managers," the designers say, "so instead of using a large variety of colors, we chose a collection of materials that were familiar to recipients— corrugated cardboard, manila tag, and shipping labels."

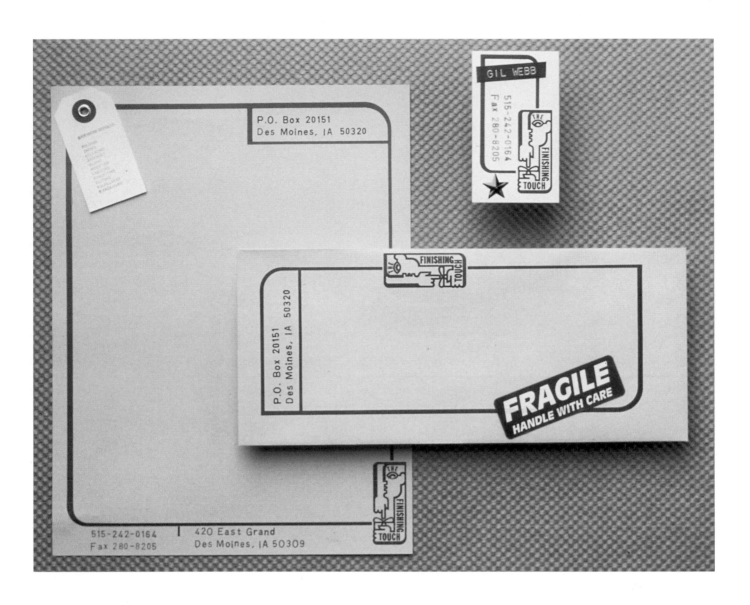

Project	The Finishing Touch
Studio	Sayles Graphic Design
Art Director	John Sayles
Designer	John Sayles
Illustrator	John Sayles
Client	The Finishing Touch

A broad color palette wasn't necessary for this corporate identity program, the designer decided. "Since the company is a finishing and binding service, we chose instead to use a variety of special effects, displaying the company's product."

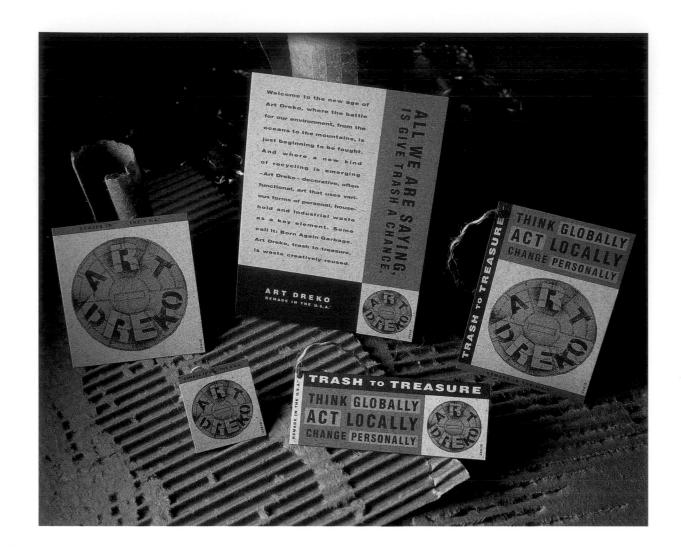

Welcome to the new age of Art Dreko, where the battle for our environment, from the oceans to the mountains, is just beginning to be fought. And where a new kind of recycling is emerging —Art Dreko—decorative, often functional, art that uses various forms of personal, household and industrial waste as a key element. Some call it: Born Again Garbage. Art Dreko, trash to treasure, is waste creatively reused.

ALL WE ARE SAYING IS GIVE TRASH A CHANCE.

ART DREKO
REMADE IN THE U.S.A.

THINK GLOBALLY ACT LOCALLY CHANGE PERSONALLY

TRASH TO TREASURE

Project	Art Dreko Collateral and Hang Tags
Studio	Mires Design, Inc.
Art Director	Scott Mires
Designer	Scott Mires
Copywriter	Robert Goldstein
Illustrator	Gerry Bustamante
Client	Art Dreko

The designer of this piece, Scott Mires, felt the client's company name, Art Dreko, demanded a simple, raw solution. Art Dreko makes decorative objects out of recycled trash.

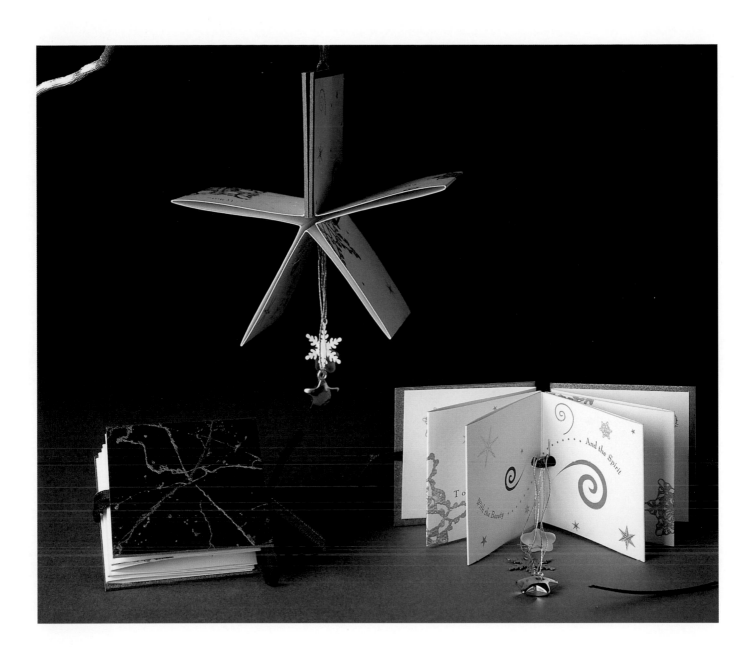

Project	1995 Christmas Ornament/Book
Studio	Artemis
Art Director	Betsy A. Palay
Designer	Laura Medeiros
Printer	Carpenter Printing
Client	Artemis

The purple and metallic silver used in this self-promotional piece were chosen because they are the colors used in the studio logo. They appear throughout this festive booklet, which does double duty as a hanging ornament.

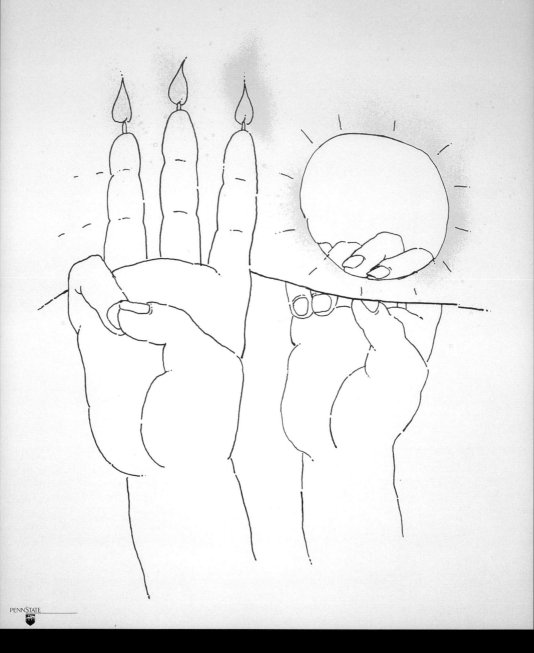

PENNSTATE

Project	Happy Thirtieth Poster
Studio	Sommese Design
Art Director	Lanny Sommese
Designer	Lanny Sommese
Illustrator	Lanny Sommese

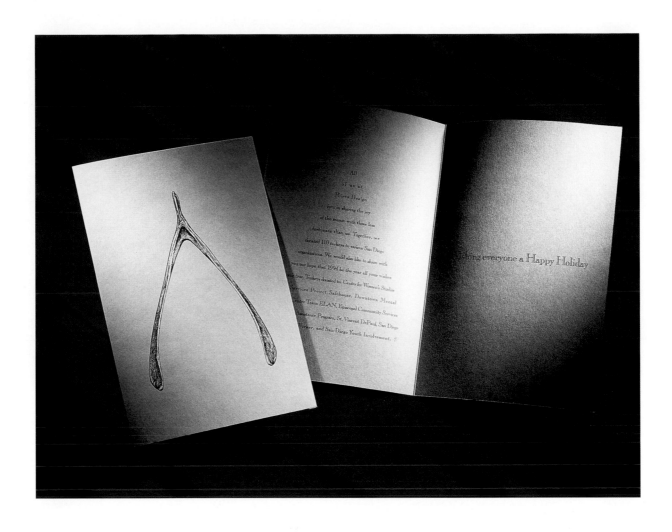

Project	Mires Design '94 Christmas Card (Wishbone)
Studio	Mires Design, Inc.
Art Director	Jose Serrano
Designer	Jose Serrano
Photographer	Chris Wimpey
Client	Mires Design, Inc.

This holiday card with a conscience reflected the social agenda at the studio. A limited number of colors were used in order that money could be saved and used instead to buy holiday turkeys for the needy.

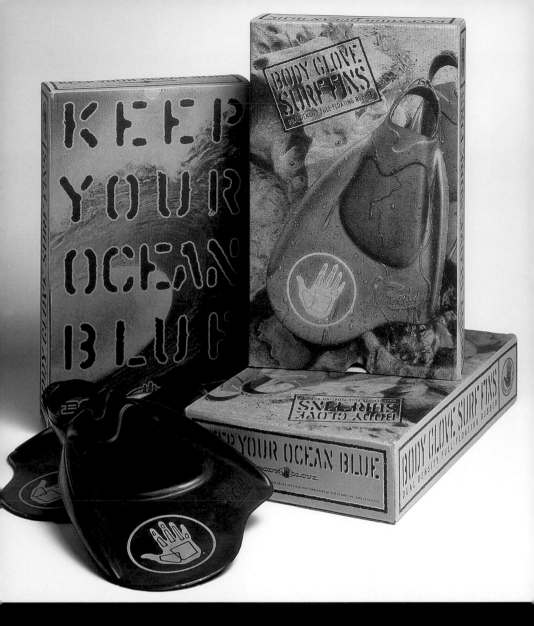

Project Body Glove Packaging
Studio Mires Design, Inc.
Art Director Jose Serrano
Designers Jose Serrano and Miguel Perez
Photographer Carl Vanderschuit
Client Body Glove

For this sports packaging, the designers say, "We used corrugated cardboard to reflect environmental consciousness, and black and metallic silver inks to attract the rugged, thrill-seeking individuals who would be most likely to buy the brand."

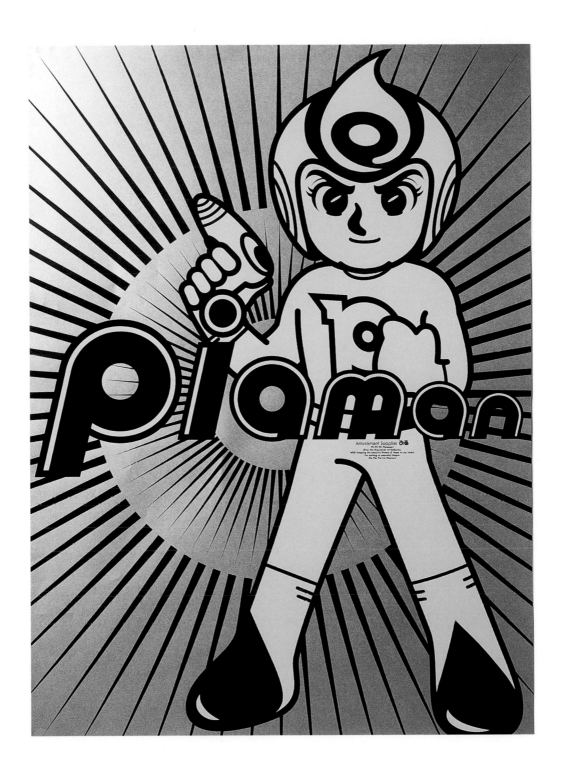

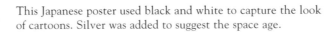

Project	Piaman Poster
Studio	Kirima Design Office
Art Director	Harumi Kirima
Designers	Harumi Kirima and Fumitaka Yukawa
Client	Pia Corporation

This Japanese poster used black and white to capture the look of cartoons. Silver was added to suggest the space age.

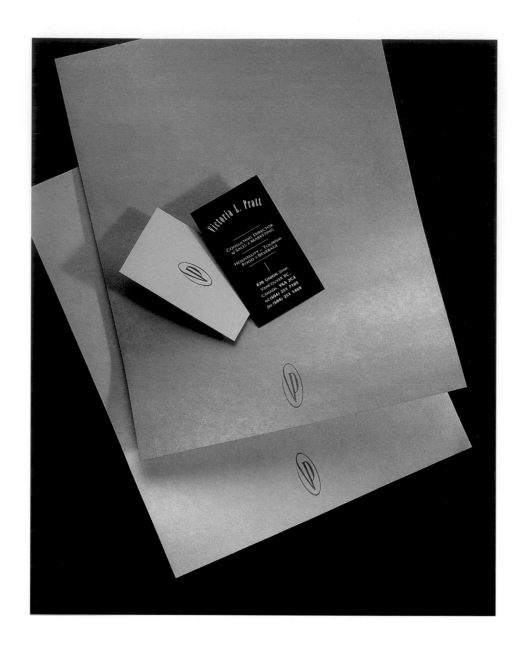

Project	Victoria Pratt Stationery
Studio	Hangar 18 Creative Group
Art Director	Sean Carter
Designer	Sean Carter
Photographer	Patrick Hattenberger
Client	Victoria Pratt

For variety's sake, half of this stationery package was printed
in green metallic ink, while the other half was printed in copper.
The two metallic colors were an unusual touch, and combine
well with the sleek logo in this elegant system.

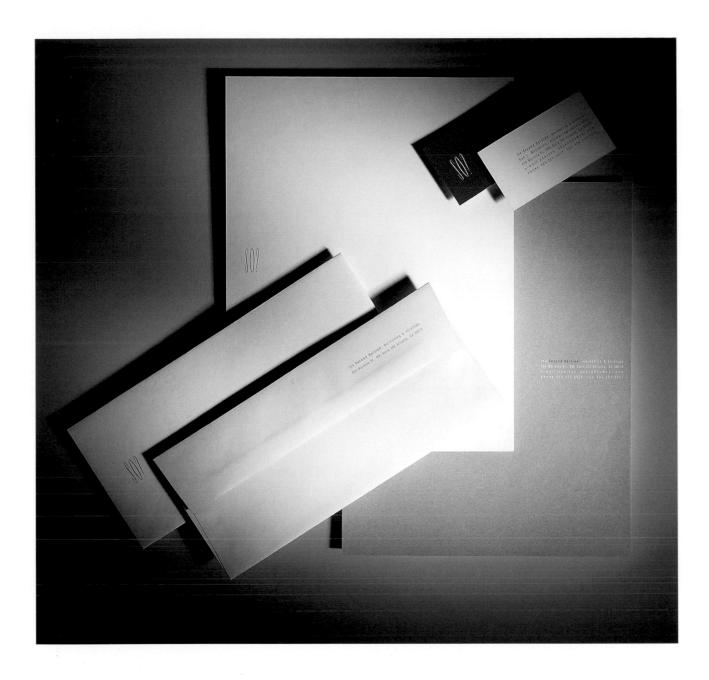

Project	Corporate Identity and Business System
Studio	After Hours Creative
Art Director	After Hours Creative
Designer	After Hours Creative
Client	The Second Opinion

This stationery is dramatic and non-traditional. The reverse side of the letterhead is a solid green color; the address appears there instead of on the front. The elegant typography and the cream color of the paper make a classic statement, creating a tension between old and new.

Project	Metamorphosis 1996 Art Auction
Studio	J. Gibson & Company
Art Director	Robert Kiernan
Designer	Todd Patrick
Client	WPA/Corcoran

Color confers sophistication on this piece, a guide to a benefit art auction. Black halftone printed over green gives the cover an elegant appearance, augmented by the cleverly deployed typefaces.

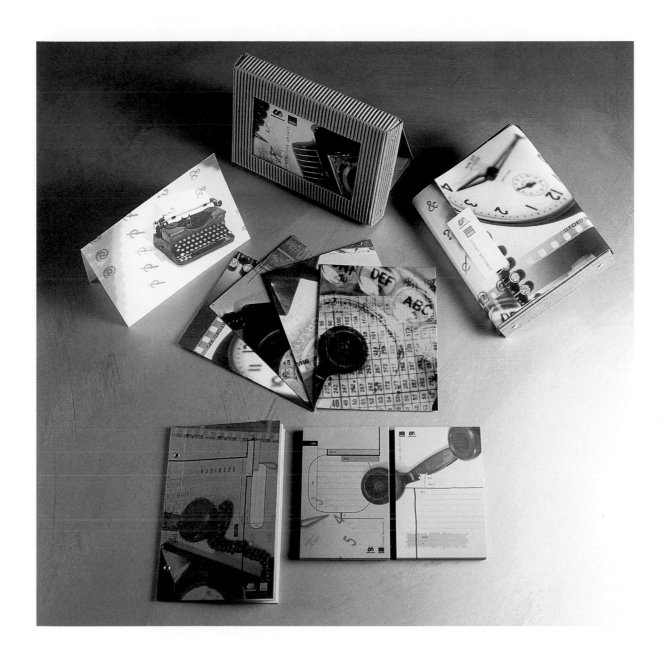

Project	Domtar Naturals Promotion
Studio	Q30 Design Inc.
Art Directors	Peter Scott and Glenda Rissman
Designer	Darrell Corriveau
Photographer	Darrell Corriveau
Printer	EPI Graphic Communications / Paper 2 Print
Client	Unisource Canada Inc.

This paper promotion combines different papers with one different PMS color per piece, creating the impression that it uses color lavishly. The choice of paper, the colors selected, and the images all fit together perfectly in this extremely effective package.

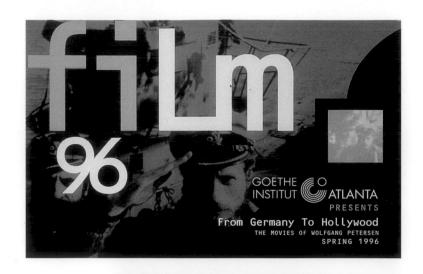

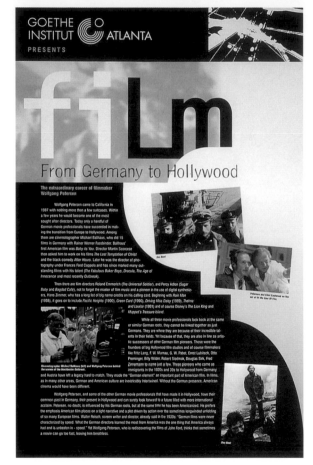

Project	Goethe Institut Film Series Brochure
Studio	Belfi Design
Art Director	Matt Belfi
Designer	Matt Belfi
Client	Goethe Institut

Another demonstration that projects done for nonprofit organizations need not look inexpensive, this brochure utilizes two colors to surprisingly rich effect. An intelligent layout, in which color and halftone play an important role, makes this pleasurable to read.

COMUNICACIÓN
BARCELONA

ÁFRICA NAVARRO

RELACIONES PÚBLICAS GABINETE DE PRENSA
MORALES 50, ENTLO 2ª, 08029 BARCELONA
TEL. 93-439 87 23, FAX 93-419 74 62
E-MAIL COMUNICACION@BCN.SERVICOM.ES

COMUNICACIÓN
BARCELONA

COMUNICACIÓN
BARCELONA

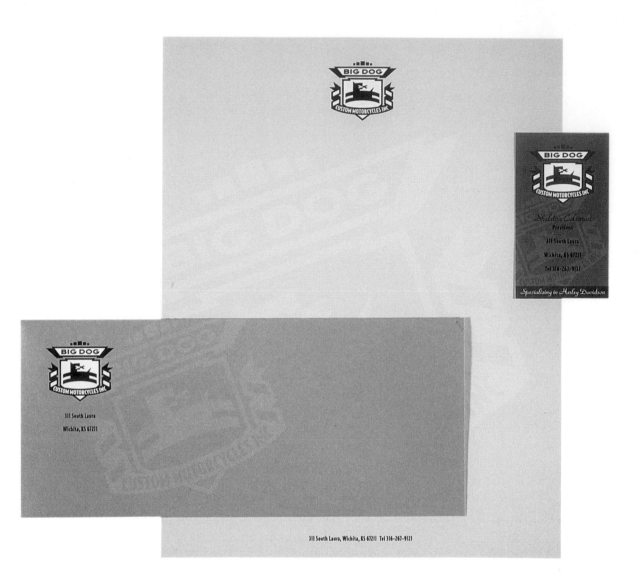

Project	Big Dog Custom Motorcycles, Inc. Stationery
Studio	Insight Design Communications
Art Directors	Sherrie and Tracy Holdeman
Designers	Sherrie and Tracy Holdeman
Illustrators	Sherrie and Tracy Holdeman
Client	Big Dog Custom Motorcycles, Inc.

Large, solid areas of bright, primary colors are the foundation of this identity, varying from piece to piece, but coordinated extremely effectively. The big, bold graphics are the perfect capstone for the building blocks of color.

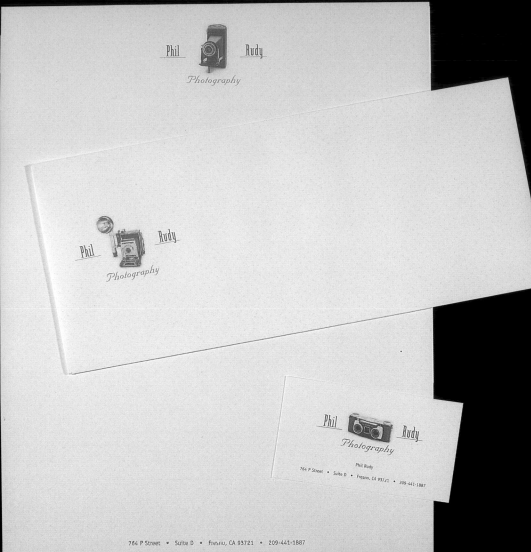

Title	Phil Rudy Photography Stationery
Design Firm	Shields Design
Art Director	Charles Shields
Designer	Charles Shields
Photographer	Phil Rudy
Client	Phil Rudy Photography

"Our client was moving into an older building," the designer says; "we wanted a look that would fit with the old downtown area but would still be contemporary." This stationery uses a contemporary color combination; mixed, it gives the photographic images a traditional sepia tone.

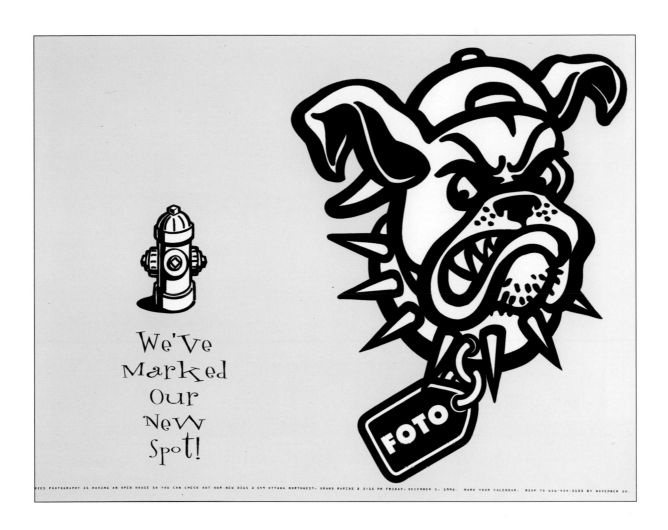

We've Marked Our New Spot!

FOTO

Title Andrew Terzes Photography Open House Invitation
Design Firm Palazzolo Design Studio
Art Director Gregg Palazzolo
Designer Gregg Palazzolo
Illustrator Gregg Palazzolo
Client Andrew Terzes Photography

Calculated to make a lasting impression, this non-traditional invitation grabs attention with its bold color palette, novel format, simple graphic, and a funny tag line, and also makes effective use of white paper.

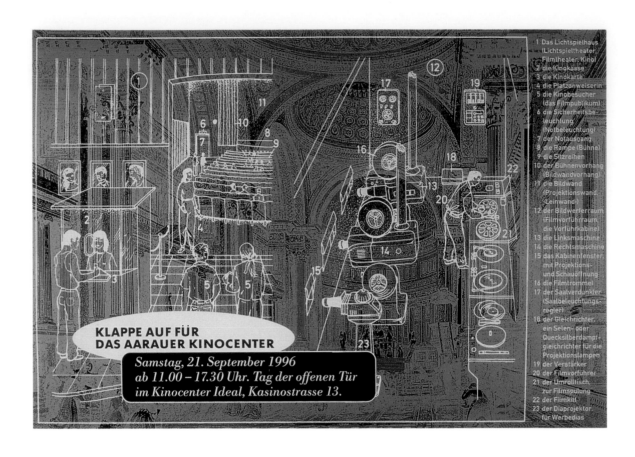

Title Kinos Aarau Postcard
Design Firm Wild & Frey
Art Director Lucia Frey
Designer Lucia Frey
Client Kinos Aarau

Offset printing and silkscreening were used on silver chromolux paper for this offbeat postcard, resulting in a surface image that changes as it reacts to light. The silver and black both reflect the light; since the yellow is flat, it sometimes disappears and sometimes becomes strongly visible.

LENGUA NATIVA

Mia Cowling

LENGUA NATIVA

Mossèn Antonino Tenas s/n
08960 Sant Just Desvern
Barcelona, España
Tel/Fax (93) 372 27 16

LENGUA NATIVA

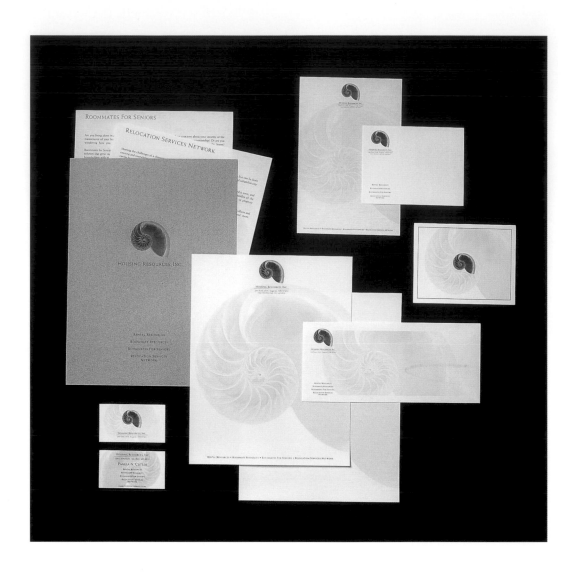

Title	Housing Resources Inc. Identity Package
Design Firm	Inovar, Inc.
Art Directors	Heather Bloom and Peter Herring
Designer	Heather Bloom
Photographer	Michael Acord, Action Plus+ Photography
Client	Housing Resources Inc.

The colors chosen for this piece combine beautifully with the color of the paper. The shell logo, shown in an elegant duotone and reproduced as a larger, halftone background image, is both clever and appropriate.

Title	Marie-Andrée Parent Stationery
Design Firm	Bazooka Design
Art Director	Brenda Lavoie
Designer	Brenda Lavoie
Client	Marie-Andrée Parent

Differing paper stocks in nicely co-ordinated colors, used for the letterhead and the business card, add pizzazz to this spectacular stationery. The faded script in the background and the central dancing figure are great design elements, used with style.

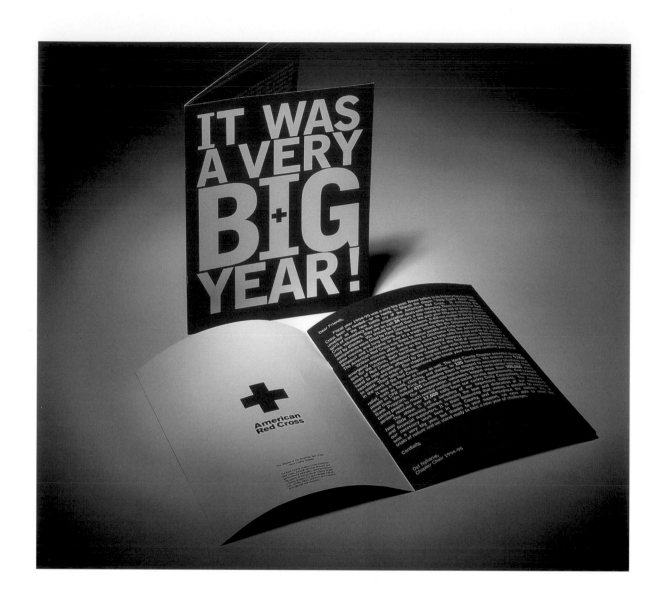

Title	American Red Cross Annual Report
Design Firm	Palazzolo Design Studio
Art Director	Gregg Palazzolo
Designer	Gregg Palazzolo
Illustrator	Gregg Palazzolo
Client	American Red Cross / Kent County Chapter

This annual report couldn't be more appropriate. It shows a completely harmonious fit between concept, execution, and client. No additional color is needed—it would, in fact, be a distraction.

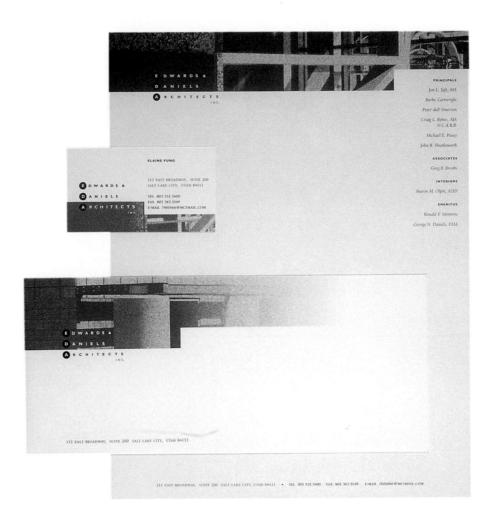

Title	Edwards & Daniels Architects Stationery
Design Firm	Huddleston Malone Design
Art Director	Barry Huddleston
Designer	Brett Lloyd
Photographer	Various
Client	Edwards & Daniels Architects

"The client wanted a colorful solution that showed the diversity of their services and products," the designers report. "Using black as an anchor color and printing the images in a color unique to each piece was an effective solution."

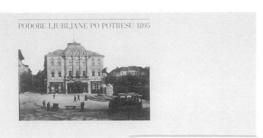

Title Podobe Ljubljane po potresu 1895
Design Firm KROG
Art Director Edi Berk
Designer Edi Berk
Client Galerija GEMA, Ljubljana

A regal set of stationery, postcards, and greeting cards celebrating the renaissance of the Slovenian capital, Ljubljana, after its devastation by earthquake in 1895, this project in gold and black reproduces classic photographs of the beautiful city.

PARK CITY OPTICAL

"The farther back
you can look, the
farther forward you
are likely to see."

WINSTON CHURCHILL

PARK CITY OPTICAL

"Vision is the art of
seeing things invisible."

JONATHAN SWIFT

Francis J. Wapner, M.D.

EYE PHYSICIAN & SURGEON

1600 Snow Creek Drive Suite F P. O. Box 2842
Park City, Utah 84060 Tel 801.647.3046 Fax 801.647.3072

PARK CITY OPTICAL

"Your eyes match
Garbo's, baby. I
wish they matched
each other."

HENNY MORGAN

P. O. Box 2842 Park City, Utah 84060

1600 Snow Creek Drive Suite F P. O. Box 2842 Park City, Utah 84060 Tel 801.647.3047 Fax 801.647.3072

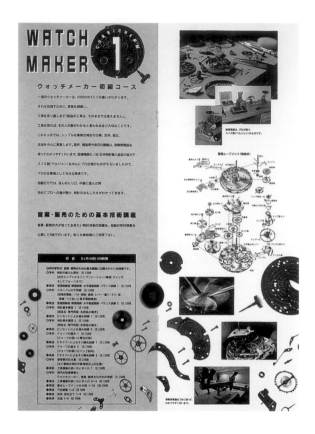

Title	Watch Maker
Design Firm	B-BI Studio Inc.
Creative Director	Koji Yamada
Art Director	Zempaku Suzuki
Designers	Zempaku Suzuki and Masahiro Naito
Photographer	World Photo Press
Client	Hikomizuno College of Jewelry

Plaudits go to the designers who could make such a complicated piece look so simple and clean. This brochure makes great use of halftone and screen printing. Color does a sort of double duty here, working well to help readers sort through a wealth of information.

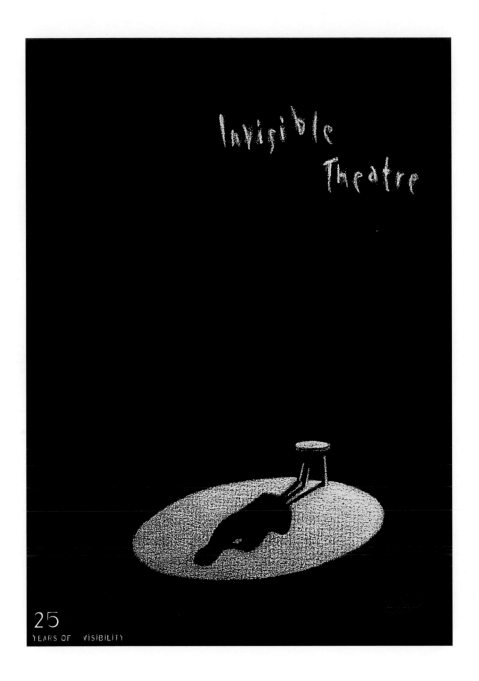

Title	Invisible Theatre Poster
Design Firm	Boelts Bros. Associates
Art Directors	Kerry Stratford, Eric Boelts, Jackson Boelts
Designers	Eric Boelts and Jackson Boelts
Illustrator	Jackson Boelts
Client	Invisible Theatre

A limited color palette was used to effective conceptual ends in this piece, as a means of suggesting invisibility. Powerful illustration, effective use of type, and dramatic preponderance of black all work well here. The spot color draws attention to the logo in the lower right corner.

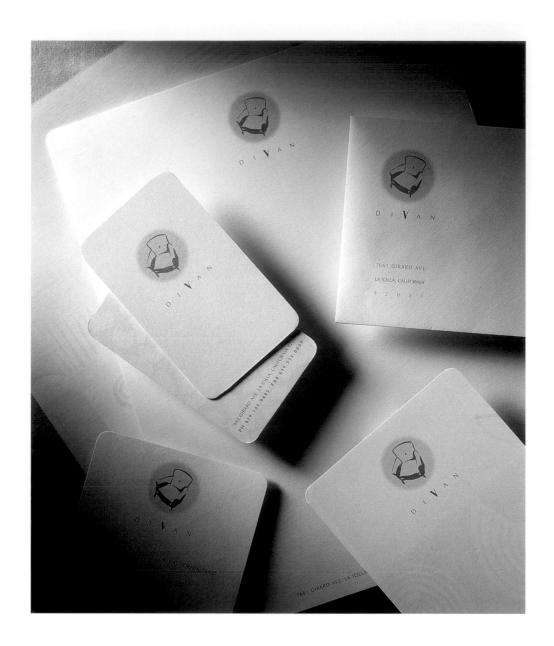

Title	Divan Letterhead Package
Design Firm	Miriello Grafico, Inc.
Art Director	Ron Miriello
Designer	Courtney Mayer
Illustrator	Courtney Mayer
Client	Divan Furnishings/Showroom

This sophisticated and contemporary stationery system is yet another project for which one main color is used on all components, but the second color differs from piece to piece. These second colors combine particularly nicely.

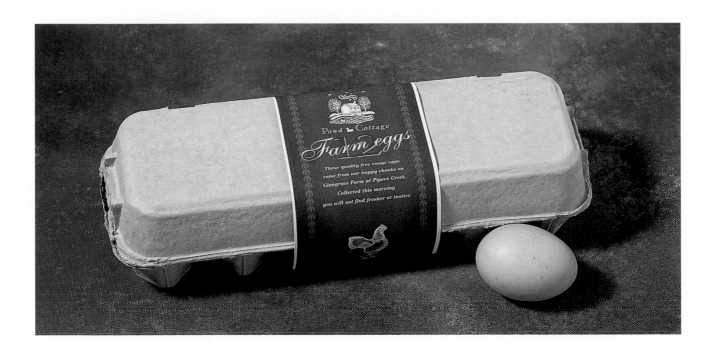

Title	Pond Cottage Eggs
Design Firm	Watts Graphic Design
Art Directors	Peter and Helen Watts
Designers	Peter and Helen Watts
Client	Pond Cottage

This wraparound label is notable for the graceful way it combines color with the printed screen. The design itself fits well with the standard egg carton. The designers report, "Due to the boutique size of the client's business and the short run, printing in two colours was the only answer."

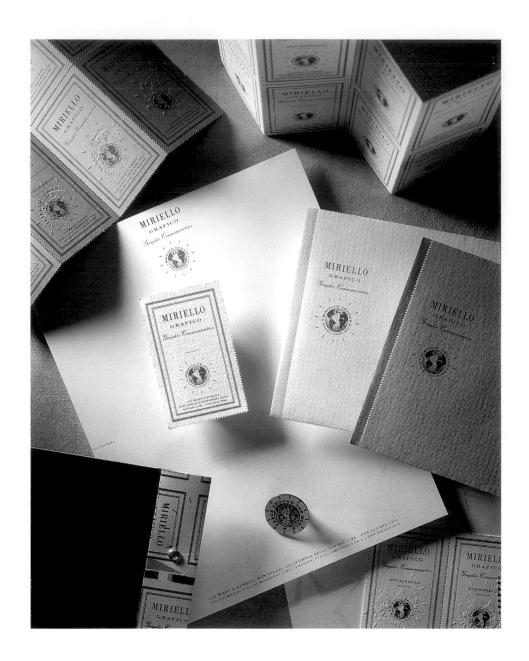

Title	Miriello Grafico Identity Package
Design Firm	Miriello Grafico, Inc.
Art Director	Ron Miriello
Designers	Ron Miriello and Michelle Aranda
Client	Miriello Grafico, Inc.

 The selection of very subdued colors gives this piece its unique character. Every detail is carefully thought through, from choice of paper to perforation and embossing, adding up to a decidedly upscale look.

118

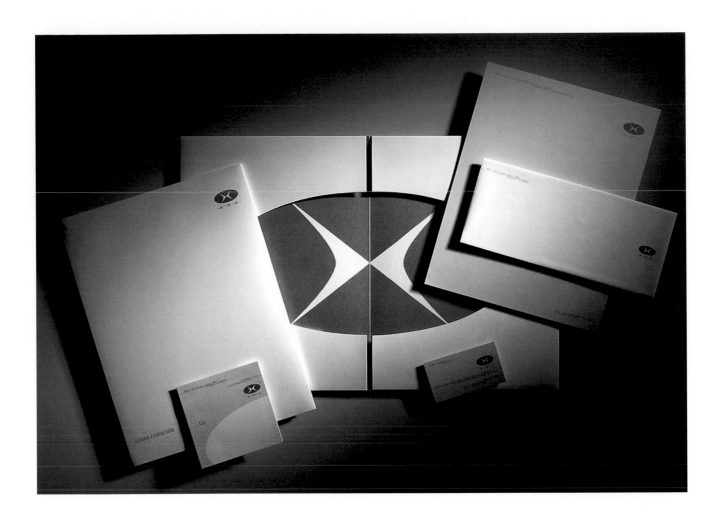

Title	ENX Business System and Corporate Identity
Design Firm	After Hours Creative
Art Director	After Hours Creative
Designer	After Hours Creative
Client	ENX

 This is a sophisticated yet friendly stationery package. The designers say they "needed to convey a clean, high-tech image, so we kept colors to a minimum...letting the bright sheet and simplicity of the mark stand out."

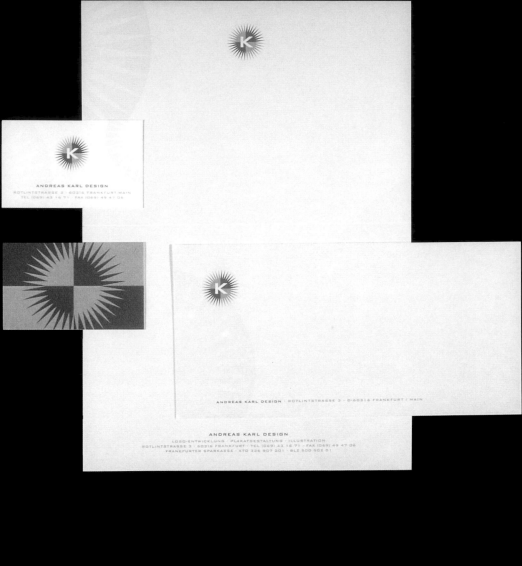

Title	Stationery
Design Firm	Karl Design
Art Director	Andreas Karl
Designer	Andreas Karl
Client	Karl Design

A simple graphic is used as a background for the reversed initial and its elements repeated throughout, making this stationery very effective.

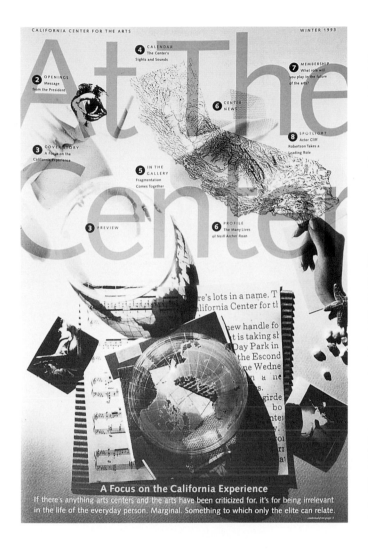

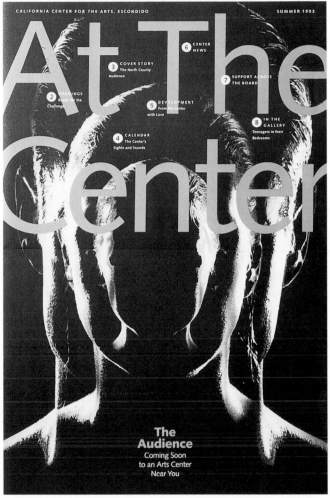

	Title	California Center for the Arts Quarterly Newsletter
	Design Firm	Mires Design, Inc.
	Art Director	John Ball
	Designer	John Ball
	Client	California Center for the Arts, Escondido

Each issue of this quarterly newsletter features a different color, for a richer effect than they could achieve otherwise.

Title	Stationery for Pascal Wüest, Photographer
Design Firm	Wild & Frey
Art Director	Lucia Frey
Designer	Lucia Frey
Photographer	Pascal Wüest
Client	Pascal Wüest, Photographer

No printing is used in this clever stationery for a photographer. A rubber stamp resembling a camera's viewfinder is used instead, with a customized two-color inkpad. The photographer's waste prints, cropped randomly, create a miniature gallery of business cards.

Title	Euro-Coin
Design Firm	Karl Design
Art Director	Andreas Karl
Designer	Andreas Karl
Client	The Graphic ECU Competition

One million people in fifteen European countries voted for their favorite design for a new, "global" European coin, and this was the winner. Additional color would have upset the perfect balance created by the two colors chosen for this elegant coin.

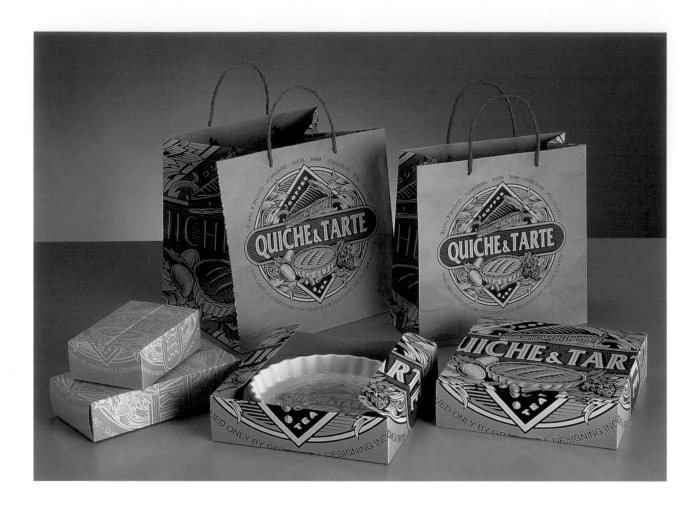

Title	Quiche and Tart Packaging
Design Firm	Graphics & Designing Inc.
Creative Director	Takanori Aiba
Art Director	Toshihiro Onimaru
Designer	Toshihiro Onimaru
Illustrator	Toshihiro Onimaru
Client	G & D Management Inc.

Black and opaque white were the two colors chosen for this unusual packaging, printed on kraft paper. This packaging could have been created with black only, but would have risked flatness; the second color adds a nice highlight and gives it flair.

three colors

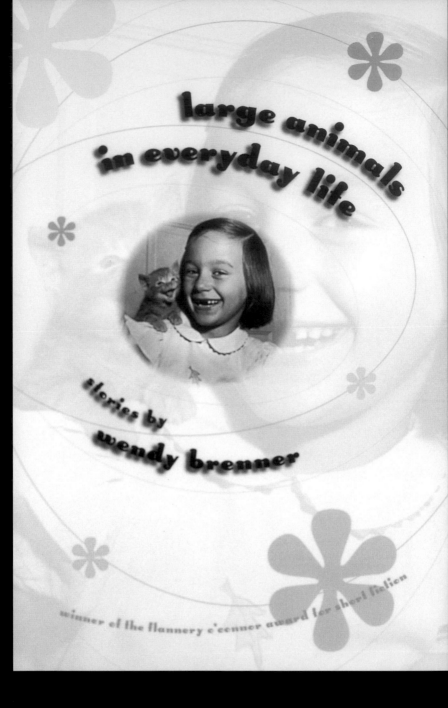

large animals
in everyday life

stories by
wendy brenner

winner of the flannery o'conner award for short fiction

Project	Large Animals in Everyday Life jacket
Studio	The University of Georgia Press
Designer	Erin Kirk New
Photographer	Walter Chandoha
Client	The University of Georgia Press

Limiting the design of the jacket to three colors helps keep the
price of a book down, but needn't detract from its visual appeal,
as this amusing and unpredictable cover shows. The colors
selected, screen printing, photograph and typography all combine
magically in this charming solution.

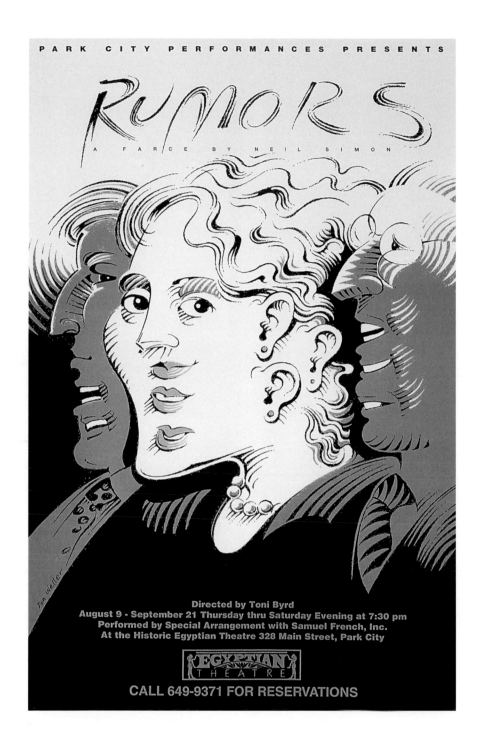

Project "Rumors" Theater Poster
Studio The Weller Institute for the Cure of Design
Art Director Don Weller
Designer Don Weller
Illustrator Don Weller
Client Park City Performances

Budget was the main reason for limiting this color palette.
According to the designer, "Three colors were cheaper than four,
no color separation was needed...and by limiting the color
palette, we could also use the purple to feature the girl's white
face and emphasize the three mouths."

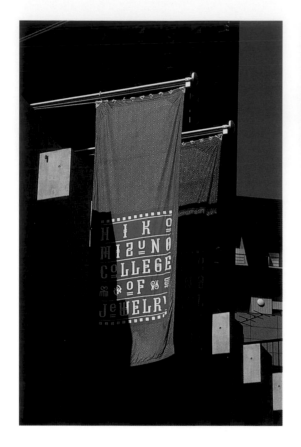

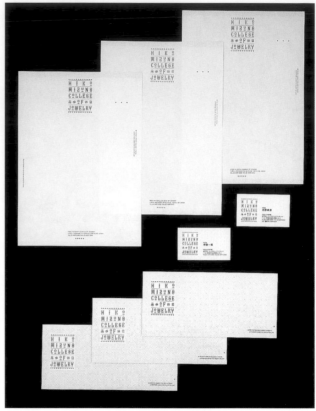

Project	Hikomizuno College of Jewelry School Identity
Studio	B-BI Studio Inc.
Art Director	Zempaku Suzuki
Designer	Zempaku Suzuki
Client	Hikomizuno College of Jewelry

Each piece in this stationery set is printed in light tan and black, with a third color varying from piece to piece, creating a full-color impression. The second color is printed in an intricate pattern, for a textile effect. Double-sided, bilingual business cards finish off this cosmopolitan identity.

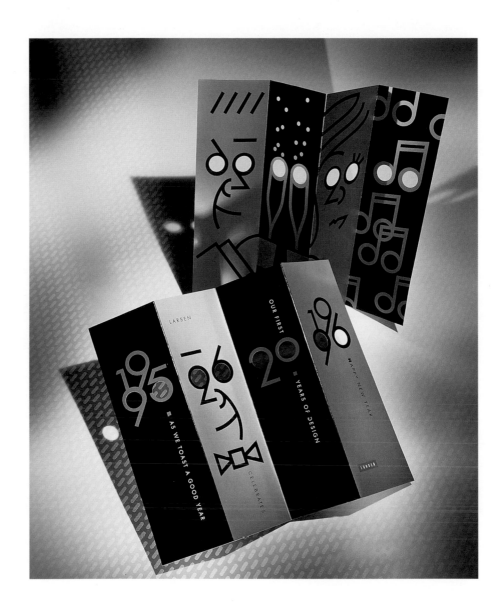

Project	Larsen Design 1996 Holiday Card
Studio	Larsen Design Office, Inc.
Art Director	Tim Larsen
Designer	David Shultz
Illustrator	David Shultz
Client	Larsen Design Office, Inc.

Creative typography and illustrations combine to make this piece memorable. Due to a short print run and a limited budget for self-promotion, it was critical to limit production expenses. In addition, the designers note, "lower press charges helped offset the die-cutting and mailing costs."

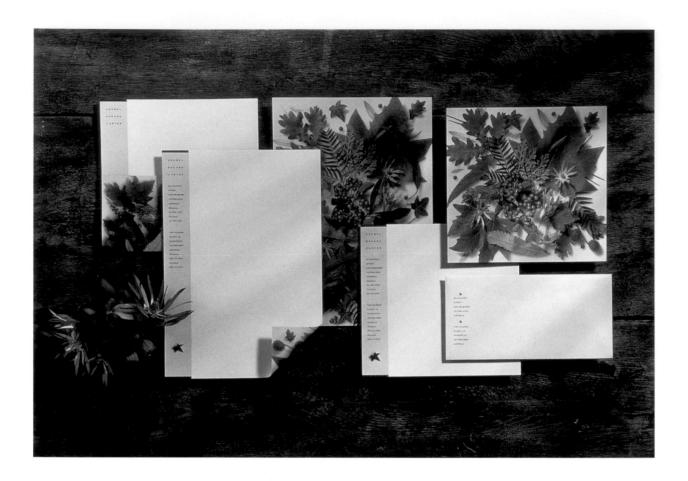

Project	Anabel Shears Carter
Studio	Harcus Design
Art Director	Annette Harcus
Designer	Stephanie Martin
Photographer	Keith Arnold
Client	Anabel Shears Carter

For this businesswoman's stationery, the designer reports, "A corporate image was desired, but the solution also reveals the client's delight in her country residence." The photograph on the back of the items highlights leaves, flowers, and objects from around her home.

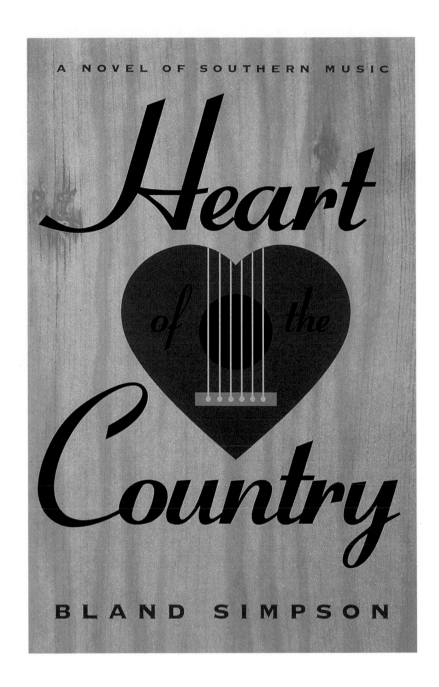

A NOVEL OF SOUTHERN MUSIC

Heart
of the
Country

BLAND SIMPSON

Project Heart of the Country book jacket
Studio The University of Georgia Press
Designer Erin Kirk New
Client The University of Georgia Press

The halftone screen background lends interest to this book jacket. Combining carefully selected typography and graphics, it all adds up to a most appropriate cover for this title.

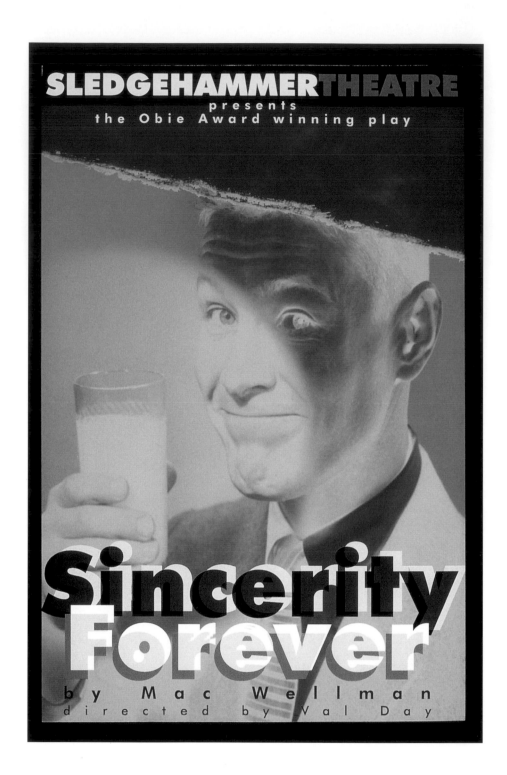

Project Sincerity Forever Postcard/Announcement
Studio MG Creative
Art Director Steven Morris
Designer Steven Morris
Photographer Stock
Client Sledgehammer Theater

The unusual treatment of the photograph makes this striking postcard announcement especially memorable. The typography is also given refreshing treatment, perhaps calling the play's title into question.

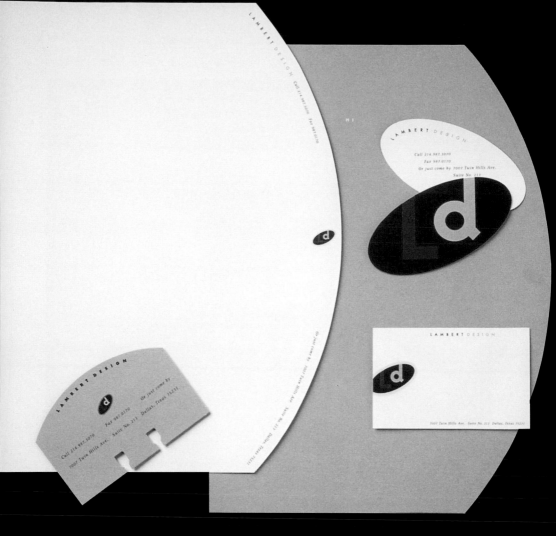

Project	Lambert Design Stationery
Studio	Lambert Design
Art Director	Christie Lambert
Designer	Joy Cathey Price
Photographer	Sam Samaha
Client	Lambert Design

For their studio stationery, the designers wanted a clean, bold look. Three colors were all that was needed; the solid yellow second sheet makes an especially vivid statement, as does the pre-printed Rolodex card of the same color.

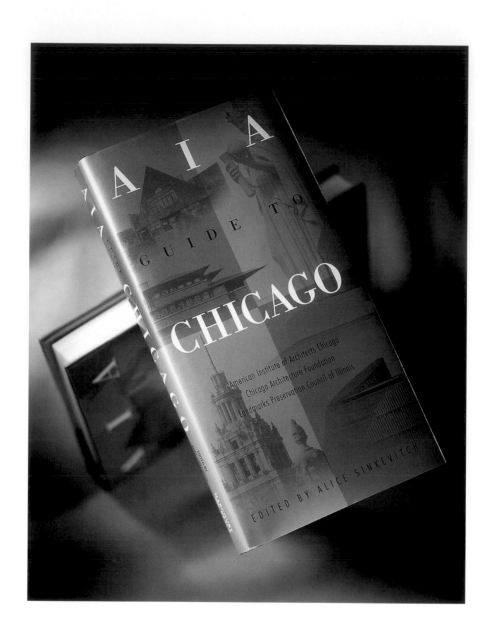

Project	AIA Guide to Chicago Booklet
Studio	Miriello Grafico, Inc.
Art Director	Vaughn Andrews
Designers	Ron Miriello, Michelle Aranda
Photographer	Various
Client	Harcourt Brace

Two metallic colors give this book jacket its unexpected quality, augmented by the ghosted photographs printed on top of the color. These were the perfect choices for this project, giving it a look at once timeless and up-to-date.

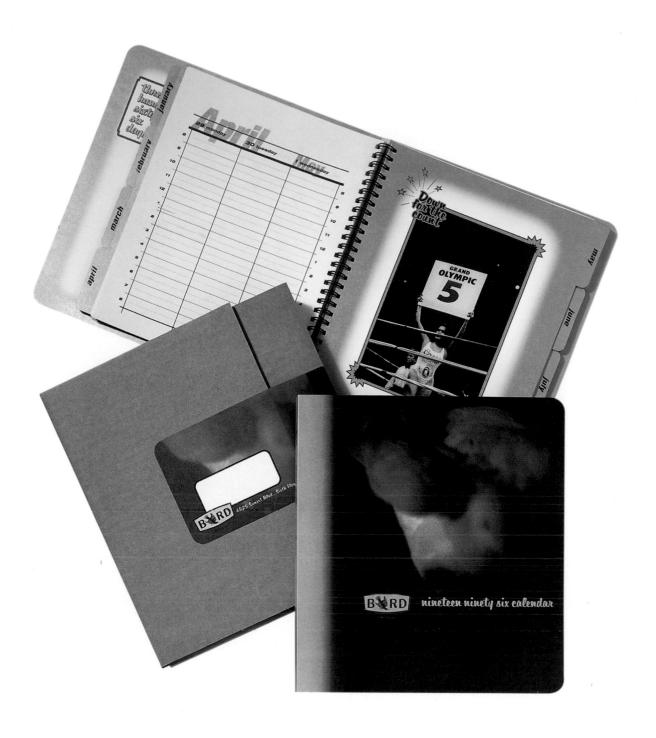

Project	1996 BRD Calendar
Studio	BRD Design
Art Director	Peter King Robbins
Designer	Peter King Robbins
Photographers	Glen Erler (cover) and Amedeo (inside pages)
Client	BRD Design

Interesting layout and imaginative use of color and typography give this calendar its special distinctiveness. The cover is in three colors, while the interior is done in two—an effective contrast.

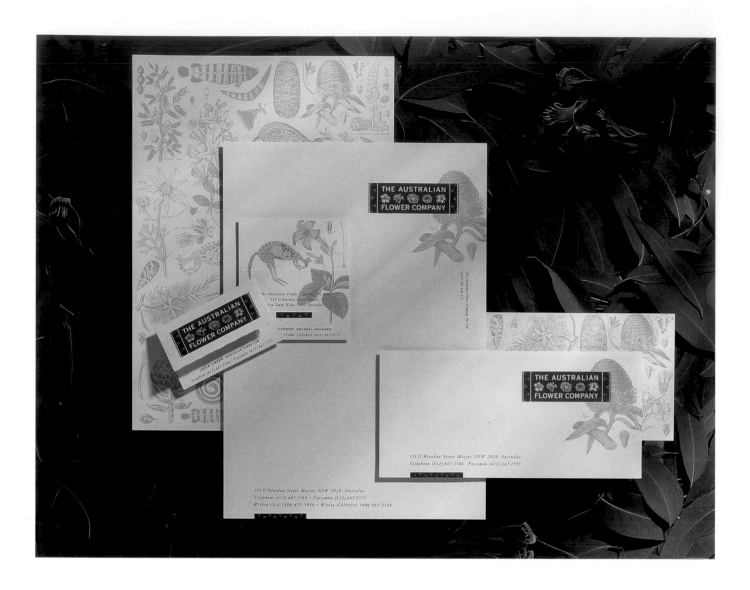

Project	The Australian Flower Company
Studio	Harcus Design
Art Director	Annette Harcus
Designers	Annette Harcus and Louis Pratt
Illustrator	Melinda Dudley
Client	The Australian Flower Company

The halftone background illustrations in this stationery look as if they came from a natural history textbook. Native Australian flora and fauna are appropriately featured throughout the system.

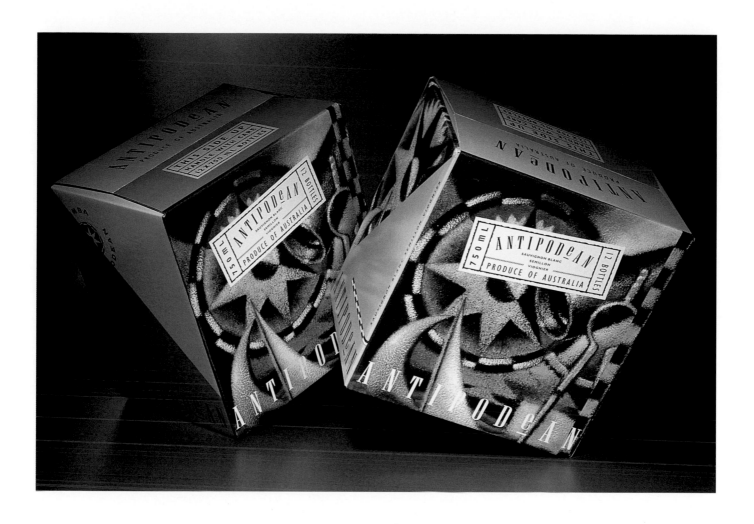

Project	Antipodean Wine Carton
Studio	Harcus Design
Art Director	Annette Harcus
Designers	Stephanie Martin and Annette Harcus
Illustrator	Paul Newton
Client	Yalumba Winery

Color plays an important conceptual role on these wine cartons. "The contrast of blue and yellow echoed the meaning of 'Antipodean', which means diametrically opposed," the designers state. The illustration used as a duotone on the carton reappears in four colors on the label.

137

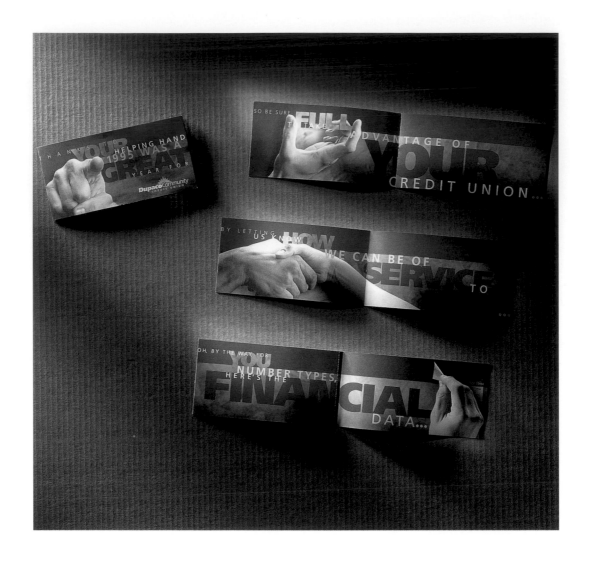

Project 1995 Dupaco Annual Report
Studio McCullough Creative Group, Inc.
Art Directors Michael Schmalz and Joe Hearn
Designer Michael Schmalz
Photographer Eric Misko
Client Dupaco Community Credit Union

The compact size, color combination (the client's corporate
colors plus black), and photography are all unexpected in this
annual report. "Because the members are the owners of their
credit union, they don't want to waste money on costly reports
that in the end get sent out to themselves."

Channel
Presents

SVEN VÁTH
from Germany

recycle or die
FARMHOUSE
EYE Q RECORDS

Desi Xol—

19.04.96

(Disc Junkies)

SVEN VÄTH
XL ¬ FEB Records Mtl
LUV ¬ Freezer GNAT ¬ Z Hard G - CKUT 90.3
 WIG ¬ Discreet Records
MiNiMONO ¬ Montréal

(Infolines)
 DNA ¬ 514.856.6446
 Synergia ¬ 514.636.4358
75W Standard Base ¬ 514.981.8488

(Tickets)

Visuals by / Justin's smart bar

O DNA records ¬ 3523, St-Laurent [514.284.7434]
O In Beat ¬ 3443, St-Laurent [514.499.2063]
O Unity ¬ 5149, St-Laurent [514.276.6932]
O En Équilibre ¬ 1647, Ste-Catherine O. [514.939.0859]
O Artthemetick ¬ 2011, Ste-Denis [514.939.0859]
O Tazou ¬ 372, Ste-Catherine O. [514.861.8767]

$20 advance / $24 at door
only 1200 tickets available
Location revealed 24h prior
 doors open at 11p.m. till....
next *Channel* event June 22, 95

Project	Be A Part Of It
Studio	Sayles Graphic Design
Art Director	John Sayles
Designers	John Sayles and Jennifer Elliott
Copywriter	Kristin Lennert
Illustrator	John Sayles
Client	Drake University

Special effects such as thermography, tipped-on material, different bindings, and unusual materials were used for this brochure, created for a university student group with a limited budget.

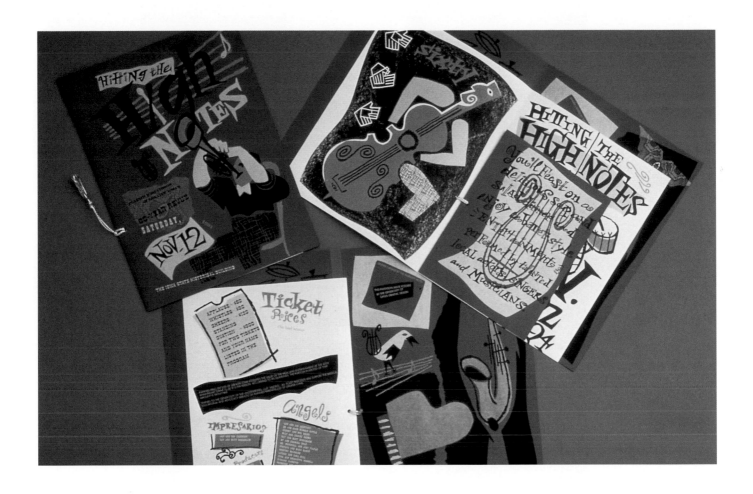

Project	Hitting the High Notes
Studio	Sayles Graphic Design
Art Director	John Sayles
Designer	John Sayles
Illustrator	John Sayles
Client	Planned Parenthood of Greater Iowa

A colored linen paper stock was used to add additional depth to the design of this brochure, and to enhance the metallic inks.

Project	"Come Home to the Hall" Invitation
Studio	Seton Hall University Publications Office
Art Director	Jean Smith
Designer	Umberto Fusco
Printer	Hatteras Press
Client	Seton Hall University Development Office

Creative use of materials makes this a most distinctive invitation. Since the event took place during holiday season, the designers report, "We chose an earthy, subtle palette to achieve a warm, comfortable feel—appealing to the desire to relax hearthside at this time of year."

Title	Jamba Juice Enertia Brochures
Design Firm	Hornall Anderson Design Works, Inc.
Art Director	Jack Anderson
Designers	Jack Anderson, Lisa Cerveny, Suzanne Haddon
Illustrator	Mits Katayama
Client	Jamba Juice

Each brochure in this set was created using three colors. When all the brochures are grouped together, they have the effect of full-color work, though the individual brochures are much simpler.

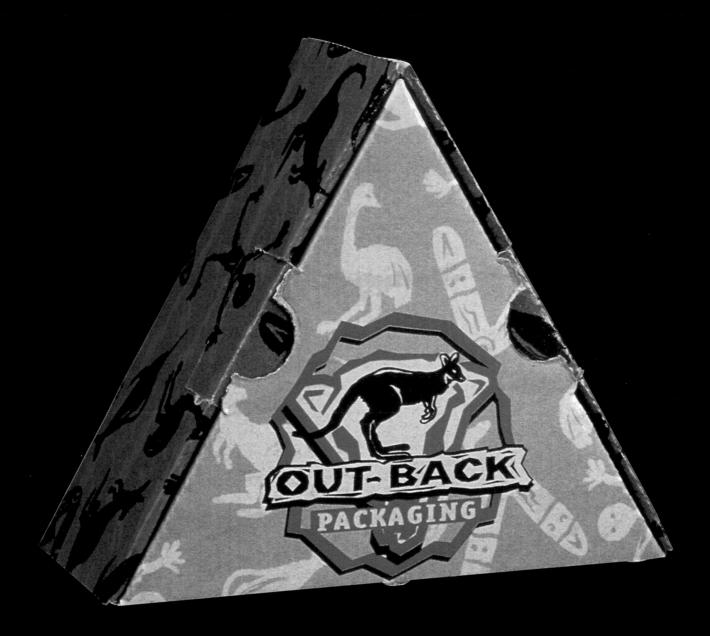

Project	Out-Back Promotional Package
Studio	Menasha Corporation—Art Center
Designer	Gary Hughes
Illustrator	Gary Hughes
Client	Menasha Corp.—Yukon Plant

This self-promotional teaser was sent to prospective users of a returnable packaging program ("out-back, get it?" the designers quip). Silkscreened in three colors, this box contained a coffee mug.

Project	San Francisco Art Institute 125th Anniversary Celebration
Studio	Ideas for Advertising & Design
Art Director	Robin Brandes
Designer	Philip Bensaid
Photographers	Jeff Richards (Burning Man, Metal & Fire) and Philip Kaake (Tower)
Painters	Francesca Pastine (oil on wood) and Leah Korican (Guardian Angel, oil on canvas)
Client	San Francisco Art Institute

The work of many different artists is represented in this piece, created for a non-profit organization. The use of halftone combined with color screen, along with the distinctive format, presents the artwork with power and integrity.

Project Maui Bath Works
Studio McNulty & Co.
Art Directors Dan McNulty and Ben Lopez
Designers Ben Lopez and Dan McNulty
Illustrators Ben Lopez and Jennifer McNulty
Client Soaptoons USA

The colors on these attractive packages are coordinated well with
the color of the soap inside. The designers explain, "Printing with
PMS colors would give the halftone image and color palette
much more punch on the shelf."

Project	SaskFILM Newsletter '95
Studio	Bradbury Design Inc.
Art Director	Catharine Bradbury
Designer	Catharine Bradbury
Photographers	Various
Client	SaskFILM

Bold use of color combines well with photography to call attention to this newsletter. Since the photography came from various sources, the designer reports, "The images were reproduced in two colors to help establish consistency and to manage the overall quality of the reproductions."

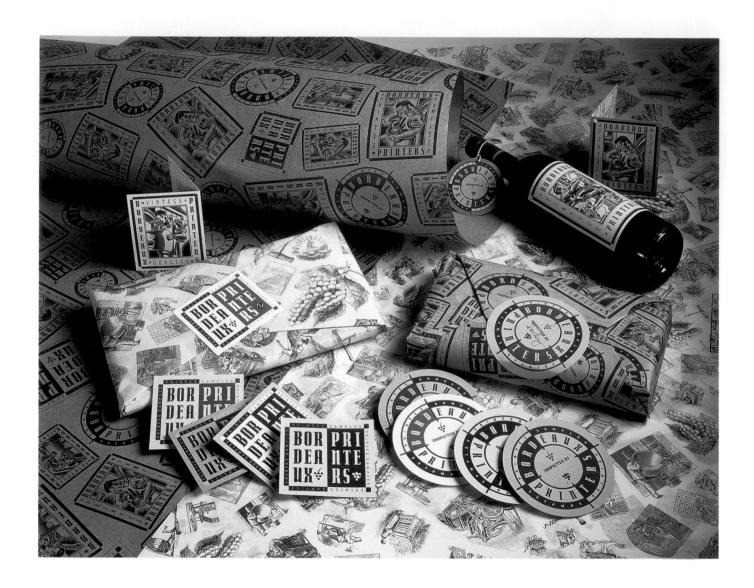

Project	Bordeaux Wrapping Paper and Hang Tags
Studio	Mires Design, Inc.
Art Director	Jose Serrano
Designers	Jose Serrano and Miguel Perez
Illustrator	Tracy Sabin
Client	Bordeaux Printers

Printers who share a name with fine wine need to wrap their jobs in papers of appropriate distinction. The designers report, "The use of limited color helped convey a feeling of old world craftsmanship."

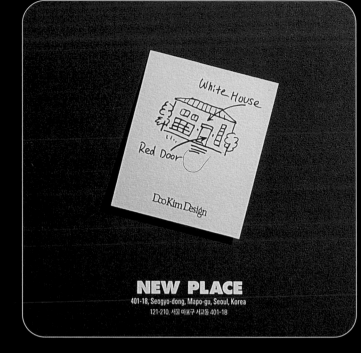

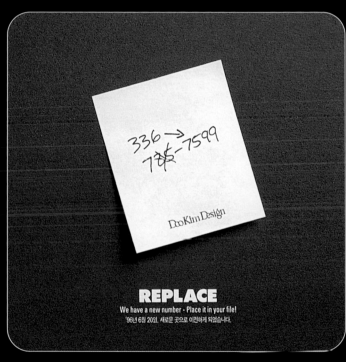

Project	Moving Card
Studio	Doo Kim Design
Art Director	Doo Kim
Designers	Dongil Lee and Seunghee Lee
Client	Doo Kim Design

For this one-time moving announcement, the designers chose to economize with a limited color palette, but compensate with bold colors and a fun, strong concept. The result was simple and perfect.

Project	Palazzolo Design Studio Identity
Studio	Palazzolo Design Studio
Art Directors	Gregg Palazzolo and Mark Siciliano
Designer	Gregg Palazzolo
Illustrator	Gregg Palazzolo
Project Manager	John Ferin
Client	Palazzolo Design Studio

This project has a richness normally associated with multiple colors. The stamp sheet made great use of color and paper. "This will be the least costly collateral package we have utilized," the designers report.

Project	Anita Mui 'True Heart' Charity Foundation Gala Dinner Souvenir and
	Invitation Card
Studio	Eric Chan Design Co. Ltd.
Art Director	Eric Chan
Designer	Eric Chan
Photographer	Cheung Man Wah
Client	Anita Mui 'True Heart' Charity Foundation

Anita Mui, a popular singer in Hong Kong, is well known for her charity
work. The organizers of this event wanted a program booklet that could be
kept as a souvenir. Tissue paper gave this keepsake a special touch of elegance.

Synoptic
Logistics Management

Synoptic
Logistics Management

20 Pollard Street, Unit 2

Richmond Hill, Ontario

Canada L4B 1C3

Dino Commodari

20 Pollard Street, Unit 2
Richmond Hill, Ontario L4B 1C3

Tel: (905) 886-5736
Fax: (905) 886-5168

Synoptic
Logistics Management

Project	Corporate Identity Program
Studio	Genesys Design
Art Director	Philip Yan
Designer	Philip Yan
Illustrator	Philip Yan
Client	Synoptic Logistics Management

These three colors were a perfect choice to express the desired balance and sophistication for this corporate identity. The use of cream-colored paper was a nice touch. Simply sophisticated graphics capped it beautifully.

Project	Salvation Army Annual Report
Studio	Corey McPherson Nash
Art Director	Phyllis Kido
Designer	Tim Chan
Photographers	Susan Archer, Geir Jordahl, Tony Rinaldo, and Terry Vine
Client	Salvation Army

This annual report was printed in three different lots. Black and opaque white was used in every lot, but the third color varied according to the lot. This is a very effective way of stretching the color palette. Paper in two different colors was also used.

Project	Green Concepts Corporate Identity
Studio	Watts Graphic Design
Art Directors	Peter and Helen Watts
Designers	Peter and Helen Watts
Client	Green Concepts

Good use of paper and imaginative diecut gave this identity its unique quality, ably supported by strong use of color. Given the client, green was a choice as conceptually appropriate as it was eye-catching.

Project	Metro Quest Corporate Identity
Studio	Watts Graphic Design
Art Directors	Peter and Helen Watts
Designers	Peter and Helen Watts
Client	Metro Quest

 The selection of a semi-transparent stock enabled the designers to print two colors on one side of this sheet and a third color on the reverse to achieve a unique "see-through" effect.

Project	QAD / IBM Partnership Guide
Studio	McNulty & Co.
Art Directors	Dan McNulty and David Bilotti
Designer	Dan McNulty
Photographer	Stock
Client	QAD, Inc.

 The great color combination of blue and green, distinctively deployed throughout this piece, make it consistently attractive. Effective use of duotone photography also makes this piece a winner.

Project **Arvind Kannabiran letterhead**
Studio Amol Sardesai Design
Art Director Amol Sardesai
Designer Amol Sardesai
Illustrator Amol Sardesai
Client Arvind Kannabiran, cinematographer

This letterhead is playful, refreshing and clever. Humorous, self-deprecating illustration combines well with an appropriately simple and subdued color palette to make this solution memorable.

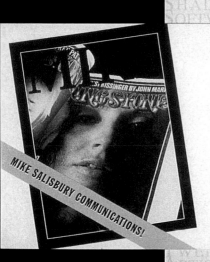

Project	Art Directors Club media kit
Studio	Platinum Design, Inc.
Art Director	Kathleen Phelps
Designer	Kathleen Phelps
Client	The Art Directors Club

For this project, a limited color palette was used primarily as an aesthetic choice, to good effect. The pocket folder was created using green paper, nicely accented by red string and red paper grommets. The placement of the sliding brochure adds drama to the presentation.

GaBi
straßburGer

wilhelm-tell-str. 4
81 677 münchen
phone 089/47 26 68
mobil 0171/51 56 886

office ★ ismaninger str. 45 ★ 81 675 münchen ★ phone 089/47 84 84 ★ fax 089/470 94 86
bankverbindung ★ bankhaus reuschel & co ★ konto 10 288 93 ★ blz 700 303 00

Project	Gabi Strassburger Letterhead
Studio	Olaf Becker
Art Director	Olaf Becker
Designer	Olaf Becker
Photographer	Olaf Becker
Client	Gabi Strassburger

If this fresh letterhead "expresses the individual style of the
client," as the designer reports, then she must have style to spare.
The unusual layout and design are perfect; the nice touch of
green on the logo adds interest to this visual treat.

Project Pacific Mountain Brewing Corporation letterhead
Studio Duck Soup Graphics
Art Director William Doucette
Designer William Doucette
Client Pacific Mountain Brewing Corporation

Colors were combined especially well in this piece, which also makes good use of screen and is distinguished by its appropriate illustration. The overall project fits the name and the product perfectly.

Project	Atlanta Ballet Bravo! Fundraiser
Studio	Belfi Design
Art Director	Matt Belfi
Designer	Matt Belfi
Photographer	Kim Kenney
Client	Atlanta Ballet

A non-profit organization can get more bang for its buck with the right solution, as this fundraising booklet demonstrates. All its elements, from typography to its selection of photographs, are effective. Simple color is added for a strong finish.

Project	EDG Summer Promo
Studio	Evenson Design Group
Art Director	Stan Evenson
Designer	Amy Hershman
Photographer	Anthony Nex
Client	Evenson Design Group

Budgetary parameters and the firm belief that "less is more" prompted these designers to limit themselves to three colors for this amusing promotional mailer.

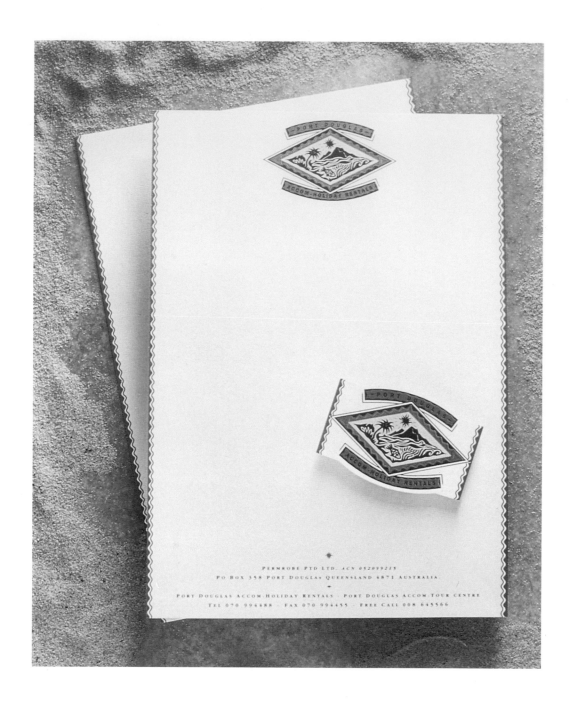

Project	Port Douglas Accom Holiday
Studio	Harcus Design
Art Director	Annette Harcus
Designer	Mario Milostic
Illustrator	Mario Milostic
Client	Port Douglas Accom Holiday Rentals

The colors of a beach vacation are appropriately chosen and used with an attractive graphic for this letterhead. Two of the colors also appear on the border.

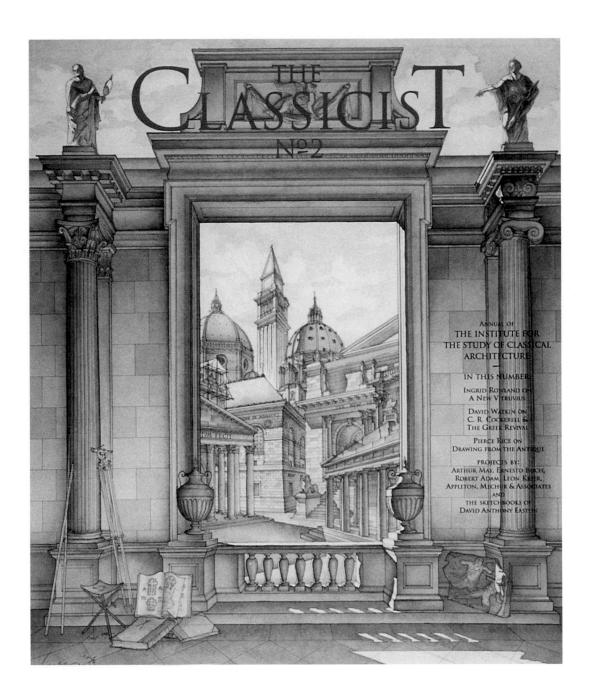

Project	The Classicist #2
Studio	Seth Joseph Weine
Art Director	Seth Joseph Weine
Designer	Seth Joseph Weine
Illustrator	Jonathan Paul Lee (cover)
Client	Institute for the Study of Classical Architecture

 This journal's name would seem to dictate its style of illustration; both are classic. The elegant cover, creative approach to typography, and simple layout give this publication an appropriately classical appearance.

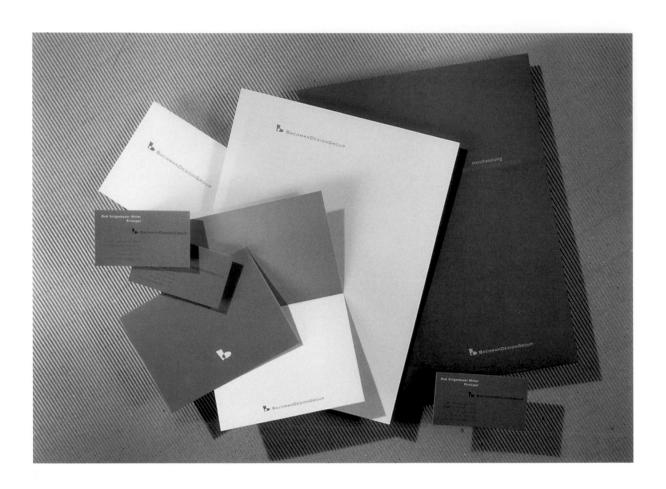

Title	Bachman Design Group Collateral
Design Firm	Bachman Design Group
Art Director	Deb Stilgenbauer Miller
Designer	Bonnie Campbell Lattimer
Photographer	Stephen Webster
Creative	Rod Johnson
Client	Bachman Design Group

This studio's identity system conveys its approach to design and planning. Staff names are reversed to emphasize personalized service to clients. The engraved folder combines identity pieces and other materials, all in different color combinations, giving this project the richness of full color.

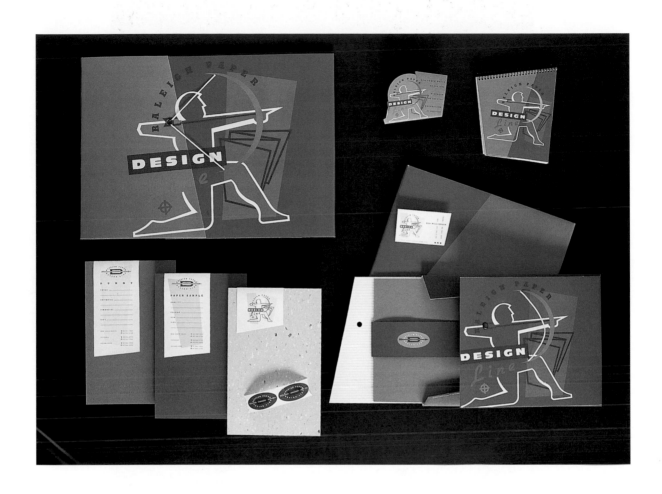

Title	Design Line Collateral
Design Firm	Harcus Design
Art Director	Annette Harcus
Designers	Kristen Thieme and Annette Harcus
Illustrator	Kristen Thieme
Client	Raleigh Paper

The three colors used in the illustrative logo on these collateral materials were also used as a bold background on the sample boxes and on the backs of the business cards. With its edges cut at odd angles, drilled holes, and attention to texture and pattern, this project holds interest easily.

Title	Anderson Printing Holiday Promo
Design Firm	Evenson Design Group
Art Director	Stan Evenson
Designer	Amy Hershman
Photographer	Anthony Nex
Illustrator	Amy Hershman
Client	Anderson Printing

The concept for this playful promotional mailer dictated the choice of colors. The red and white on the cans combined well with the colors used in the Anderson's Printing identity to result in this holiday gift package.

Title	J & H Business Risk Brochure
Design Firm	Evenson Design Group
Art Director	Stan Evenson
Designer	Amy Hershman
Photographer	Various
Client	Johnson & Higgins

 A good combination of colors was chosen for this piece, and astutely deployed to create an entirely appropriate sense of drama. This brochure makes the right kind of impact for a project devoted to the subject of risk management: serious and reassuring.

QUANTE VITE HAI PER FUMARTI QUESTA?

NON FUMARE. FALLO PER TE.

istituto oncologico romagnolo

per la lotta contro il cancro in romagna

MATITE GIOVANOTTE(FO) - Stampa: Filograf Litografia s.r.l. - Forlì

Title	Don't Smoke—Do it for you
Design Firm	Matite Giovanotte
Art Director	Barbara Longiardi
Illustrator	Barbara Longiardi
Client	Istituto Oncologico Romagnolo

This poster, created for a nonprofit health agency, utilizes three colors in such a way that no more could be desired. The dramatic yellow background and straightforward black type set the right mood, while the magenta accents are equally effective.

Title	Pine Valley Packaging
Design Firms	Love Packaging Group and Insight Design
Art Director	Tracy Holdeman
Designer	Tracy Holdeman
Photographer	Digital Rock Island Studios
Illustrator	Tracy Holdeman
Copywriter	Clark Jackson
Client	The Hayes Co., Inc.

Kraft paper was used to create the "natural" look of these charming packages for a bird house and bird feeder, in an exemplary instance of the right colors being applied to the right materials for exactly the right result.

Title	OXO Good Grips Barbecue Tools Packaging
Design Firm	Hornall Anderson Design Works, Inc.
Art Director	Jack Anderson
Designers	Jack Anderson, Heidi Favour, John Anicker, David Bates
Photographer	Tom Collicott
Client	OXO International

The designers chose the Kraft box to give the packaging a warmer feel, and created an attractive composition with the implements and the shadow of the grill.

Title	Novell Corporate Identity Guidelines Brochure
Design Firm	Hornall Anderson Design Works, Inc.
Art Director	Jack Anderson
Designers	Jack Anderson, Bruce Branson-Meyer, Larry Anderson, Don Stayner
Photographers	Various
Copywriter	Pamela Mason-Davey
Client	Novell, Inc.

This graphic standards manual is admirably designed. It's simple, easy to understand, and makes effective use of color. The corporate colors were used throughout the brochure, emphasizing its purpose.

Raising standards **+** **▬** **lowering impacts**

LONDON ELECTRICITY

Nuclear power produces almost no atmospheric emissions but raises health and environmental concerns because of the risk of radioactive leaks and the storage of radioactive waste. In 1994 London Electricity's share of the electricity supply market in England and Wales was 6% which equates to approximately 16 TWh.

London Electricity investments in generation
In common with many of the RECs, we actively explore opportunities to invest in and develop new generation plant using modern cleaner, more efficient or renewable technology. These investments, including any in renewable generation, must fulfil financial criteria and satisfy our economic purchasing obligation as required by our public supply licence.
To date our investments in generation projects are:
- Barking Power, a 1000 MW combined cycle gas turbine station, in which our investment represents 270 MW.
- South East London Combined Heat and Power (SELCHP), the second waste to energy plant in the UK, which began operating in South London in 1994. It produces 30 MW of electricity from waste that would otherwise be landfilled.
- Through our joint venture company, Combined Power Systems (Southern) Ltd, we installed 6 small combined heat and power units during 1994/1995 with a total installed capacity of 1 MW. This brought our total number of units installed in the south of England since 1991 to 55 with a total capacity of 7 MW.

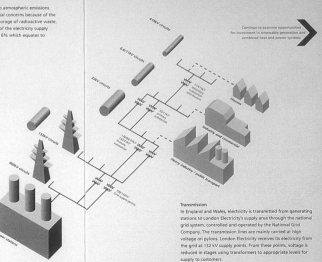

Continue to examine opportunities for investment in renewable generation and combined heat and power systems

Transmission
In England and Wales, electricity is transmitted from generating stations to London Electricity's supply area through the national grid system, controlled and operated by the National Grid Company. The transmission lines are mainly carried at high voltage on pylons. London Electricity receives its electricity from the grid at 132 kV supply points. From these points, voltage is reduced in stages using transformers to appropriate levels for supply to customers.

CO₂ emissions per GWh (tonnes)
National Power, PowerGen

National Power	836
PowerGen	820

SO₂ emissions per GWh (tonnes)
National Power, PowerGen

National Power	9.60
PowerGen	10.44

NOₓ emissions per GWh (tonnes)
National Power, PowerGen

National Power	2.70
PowerGen	2.57

Source: National Power Environmental Performance Review '95 and PowerGen Environmental Performance Report 1994

Estimated generated emissions from electricity supplied by London Electricity (tonnes)

CO₂	9,792,000
SO₂	121,120
NOₓ	32,960

(Based on Electricity Association average emissions/unit data)

Title	WPP Space Programme
Design Firm	Sampson Tyrrell Corporate Marketing
Art Director	David Freeman
Designer	Steve Edwards
Account Team	Sarah Ritchie Calder and Helen Peterson
Client	WPP Group PLC

The colors of this internal workbook strongly communicate the nature of the space program. Its choice of typography is also appropriate. Its simple charts and graphs are easy to read, making it quite user-friendly.

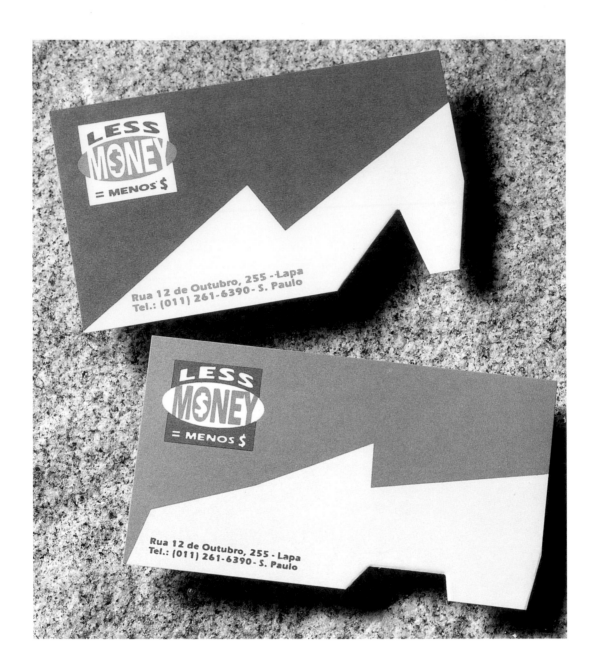

Title	Less Money Brand
Design Firm	Animus Comunicao
Art Director	Rique Nitzsche
Designers	Rique Nitzsche and Felicio Torres
Client	Less Money

Men's and women's shoes at low cost are the product cleverly advertised on these business cards. Color is an integral part of the message, as the logo and silhouetted footwear show.

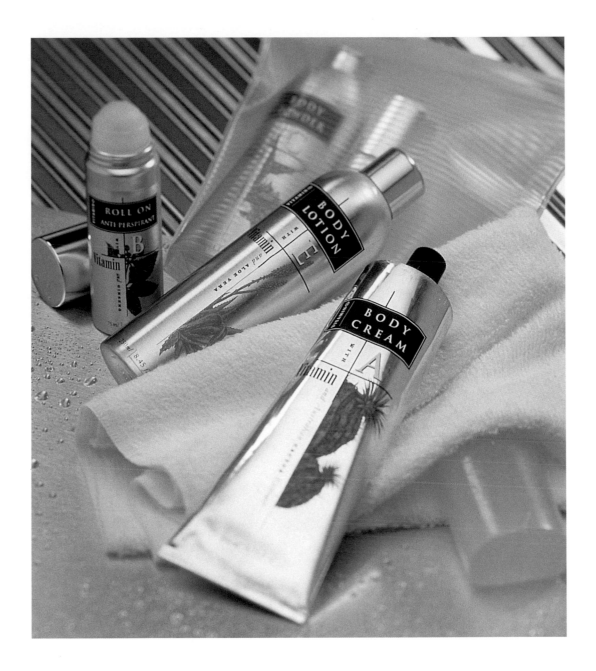

Title	Vitamin + Body Care
Design Firm	Harcus Design
Art Director	Annette Harcus
Designers	Mario Milostic and Annette Harcus
Photographer	Keith Arnold
Illustrator	Simon Fenton
Client	Trelivings Australia

Black and white were used on every package in this elegant set, with an additional color varying from piece to piece. All are designed in such a way that the aluminum packs are highlighted, for an exceptionally clean look.

indices

by client &
design firm

index by client

index by design firm